The
FOCALGUIDE

to
Effects and Tricks

Günter Spitzing

Focal Press
London & Boston

Focal Press

is an imprint of the Butterworth Group

which has principal offices in

London, Sydney, Toronto, Wellington, Durban and Boston

First published 1970
Joachim F. Richter, München, 1970
© Verlag Laterna magica

Translated by Fred Bradley, FRPS AIIP
from Das Verrückte Fotobuch

Spanish edition, 'Trucos y Efectos'
Ediciones Omega, S.A., Barcelona

English edition first published 1974
 Reprinted 1974, 1975, 1976, 1977, 1978, 1979, 1981

© Focal Press Ltd, 1974

ISBN 0 240 50761 4

Printed in Great Britain by
Thomson Litho Ltd, East Kilbride, Scotland
and bound by Hunter & Foulis, Edinburgh

Contents

Bending the Rules

Normal photography follows certain rules to obtain reasonably true-to-life results. If we depart from those rules, we may get pictures that are distorted in shape, tone, clarity, colour and so on. Radical departures can make the image an unrecognizable reproduction of the subject. Herein lies the clue to much effects photography. We bend the rules so that the subject takes on a particular aspect that puts across our ideas better than a straight reproduction.

Wrong exposure – with a purpose

The simplest possibility of obtaining unusual pictures is the choice of a totally wrong exposure – with "totally" the operative word. Exposure variations of the determined value of ± 1 and even ± 1 1/2 lens stops are variations comfortably within the range of most ordinary photography; in addition we must all but completely write off the entire range of underexposures for our special purposes. All too often extremely short exposures are used especially for colour transparencies to obtain silhouette effects or contrast effects with suitable subjects. On the other end of the scale a really "juicy" overexposure produces rather sugary results. The following table shows exposure situations which can be made to yield special effects in certain conditions.

As you study this table it cannot escape you that the colour negative film obviously plays a particularly important part in this practice of deliberately wrong exposure. I can merely underline this fact and add a cautionary "BUT", to be ignored at your peril.

The use of colour film is, however, feasible only if you produce your own colour enlargements (but you may safely leave the development of your colour negatives to a reputable establishment). As your own colour worker you can, with the aid of filters, influence the residual colours in the overexposed negatives in almost any desired direction. This applies particularly to subjects in indirect contre-jour light. By the way, enlargements with colour hues can also be made from black-and-white, overexposed, silhouette-type negatives. The result: figures in colour standing out against a white background. Colour enlarging is far less difficult than you expect before you try it in practice.

EXAMPLES OF OVEREXPOSURE EFFECTS

Suitable lighting	Examples of subjects	Special properties of subject	Effect	Suitable type of film	Specially suitable types of film
Direct contre jour light (sun, flash, filament lamp)	Portraits, especially with long hair; persons in flowing, sometimes translucent dress, or drapery, flowers in dense grass or branches	Brightly lit portions should, if possible, not be too large	Overexposed portions – about 3 lens stops and more – burn out, appearing as white outlines or patches. Normally dark shadows are rendered light	Colour transparency, colour negative, black-and-white document material	Colour negative
Indirect contre jour light (object in front of a white cloudy sky, an illuminated wall)	Person in a gateway, in a door in front of a window with sky as background, plants in front of transilluminated translucent wall	Typical situation for silhouette effects with normal to short exposure	Long overexposure merges the detail, sometimes even the colour, with the background. Good detail appears in the dark main subject. Its colour tone depends on the colour of the surrounding reflecting surfaces. Pictures of a soft airy character are the result	Colour transparency	Colour negative
Indirect lighting: (illuminate walls and ceiling with flash or photo flood. Illuminate a tent of translucent paper built round the object)	Still life, flowers, portraits (possibly with extremely dark make-up of eyes or lips)	Subjects in shadowless illumination. If possible, object and background should be in similar tones. Only small details may be completely dark	A picture with uniformly bright tones from which only a few dark spots stand out is most simply obtained with 2–$3 \times$ overexposure	Colour negative, black and white, exceptionally colour transparency	Colour negative, black and white
Shadowless (indirect) or shadow-poor illumination (softening of shadows with supplementary light sources is sufficient)	Whole-figure portrait in profile, group in front of dark background (black velvet night sky)	The subject tone should be as light as possible and be devoid of dark detail	With 3–$4 \times$ overexposure white "halo silhouette" will be produced in front of a dark background	Black and white, colour transparency, document copying material	Black and white

Extent of overexposure

The feasible and recommended extent of overexposure depends on the subject as well as the film material. In our examples this range lies roughly between 2 and 4 lens stops. The basic exposure is naturally for the darkest pictorially important subject portions when negative film, and for the brightest portions when reversal film is used – at least when you work with light that you regard as white. When the light is coloured you must consider two special points:

Exposure meters – especially the modern, battery-operated CdS measuring instruments – react like the proverbial bull: red makes the needle "kick" violently; whereas blue leaves them comparatively cold. We obtain a fairly normally exposed result if we open up about 1 lens stop beyond the measured value for subjects in red light. Blue light, on the other hand, calls for stopping down by roughly the same amount. Fortunately, green and yellow require no correction. The term "normal" exposure with colour effect lighting is, however, somewhat open to interpretation, depending on the effect required.

With excessive overexposure colour reversal film reproduces colours as white. The excess of light required for this whitening of the colours differs, however, not only with the various types of film, but also with the various colours. If necessary, this property of the colour films can be utilized also for colour trick compositions. Some colours can be eliminated from the pictures with a hefty overexposure, whereas others – they should be chosen as dark as possible – will be preserved.

Exposure tests on selected films

I did not test all the types of film but want to describe my trials with a small selection to give you at least a few pointers for your own experiments. I started with photographing the Agfa Graduated Colour Chart No. 2 (with strips in red, yellow, green and blue) first on Agfachrome 50 L in the light of a 1000 W Philips PF 800 R halogen lamp, then on Agfa CT 18 and Kodak Ektachrome in daylight at 10 different exposure times each. I followed this

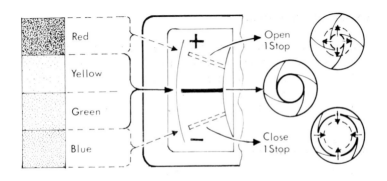

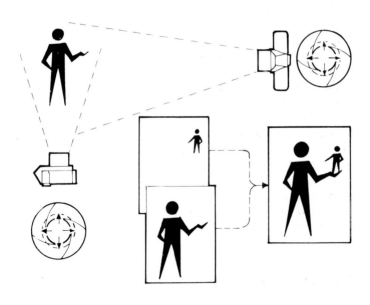

Coloured lighting arrangements can affect exposure meter readings (**top**). Red lighting can give too high a reading resulting in underexposure. Blue light may cause the meter to read low, leading to overexposure. When binding two or more slides together (**bottom**) slight underexposure of each is generally advisable.

with serial exposures on Agfachrome with Philips Comptalux Flood window display lights (see Table) in red, yellow, green and blue. The picture included the lamp as a contre-jour light source. A portrait model occupied the foreground. During the basic measurement I of course applied the exposure corrections necessary for red and blue light. The table below shows the results of the evaluation.

OVEREXPOSURE IN LENS STOPS OR EXPOSURE STEPS NECESSARY TO REPRODUCE COLOURS AS WHITE

Colour	Colour chart Agfachrome 50L Halogen	Colour chart CT 18 Daylight	Colour chart Ektachrome X Daylight	Coloured Comptalux reflector (brightest spot) Agfachrome 50L
Blue	9–10	8–9	9	8
Green	7– 8	5–6	6	7
Yellow	6– 7	5–6	6–7	9
Red	7– 8	7	8	8
Remarks	Colour rendering remains neutral also with overexposure. Velvet black is still black at the 5th step	From 3 lens stops overexposure the blue tones clearly shift towards green, the red tones towards purple. Velvet black is still black at the 4th step	From 2 lens stops overexposure purple tendency of "white" Velvet black is still black at the 3rd step	Overexposed red acquires a purple, green a cyan hue

Very slight overexposure can be used for various other experiments. Sandwich slides (p 150) are particularly successful if the various transparencies of which they are to be made up are overexposed at a good half to a whole lens stop. Artificial-light film used in daylight (p 128) should also be overexposed to the tune of $1/2$ to 1 lens stop.

Double and multiple exposure

One of the most objectionable – because most frequent – sources of photographic faults in the past used to be the accidental dou-

ble exposure. Fortunately this was a long time ago. Almost all modern cameras include a double-exposure lock which prevents this; but the solution of this problem has created a new one. Whereas accidental double exposures are prevented, deliberate double or multiple exposures are made at least more difficult. The only modern cameras without the double exposure lock are the professional models for medium- and large-format sheet film. Fortunately, however, most other types of camera can be persuaded – by fair means or foul – somehow to deliver multiple exposures.
Here are some of the methods of bending your camera to your will:

Long-time method

If you want long-time exposures to affect the same piece of film, simply mount your camera on a tripod, open the shutter and leave it open. A cable release with a lock is both very useful and versatile.
The exposure time is counted: one-and-two-and-three-and etc. A lens cap, a hat, a fur cap, a piece of black velvet, or a changing bag is placed over the lens to complete the several parts of the exposure. Only after the last "instalment" must the shutter be closed.
Complicated? Not at all. I have often used up yards and yards of colour film with this method. The procedure, although a little cumbersome, is quite effective.

Overriding the double exposure lock

The following procedure will be found reliable with almost all 35 mm cameras:
1 Wind the film wind and rewind knobs taut
2 Make the first exposure
3 Hold the rewind knob firm, depress unlocking button for rewinding, and at the same time operate the film transport lever (it would be useful to have at least three hands!)

4 You can now make the second exposure (although the shutter was wound, the film was not transported)
5 If necessary, repeat the whole procedure from the start.

I have used this method with the Leica M3, the Leicaflex, the Exa Ia and a panoramic camera (p 85). Before trying it with any particular camera, you would, however, be wise to make a test with a piece of waste film with the camera back open.

Note that the rewind knob must be held firmly in position. But if you tighten it with too much force while pressing the rewind unlocking button, the film in the camera will creep slowly backwards. This is one very serious source of fault.

Sore point number two: when the film is at last transported, the rewind unlocking button often does not return to its rest position quickly enough; as a result, the film will perhaps be advanced through three quarters instead of a whole frame. To avoid overlapping you must either sacrifice a frame or, if this seems too much, rewind the film a little (about half a frame), and then transport it through two frames. In some types of camera the rewind knob need not be immobilized. All you have to do is to press the rewind unlocking button while winding the film transport knob to prevent the action of the transport mechanism on the film. This is, however, a matter of trial and error.

On some older cameras with shutter speed knobs that rotate as the film transport is operated, you can retension the shutter by turning the speed-setting knob against the spring. The film then remains untransported.

Method of rewinding

If your 35 mm camera does not lend itself to this procedure, try the following method:

1 Firmly tighten the rewind knob
2 Make the first exposure
3 Mark the position of the rewind knob with a line on the knob itself and one on the camera top with a soft pencil.
4 Transport film normally
5 Rewind film very carefully till the two lines match

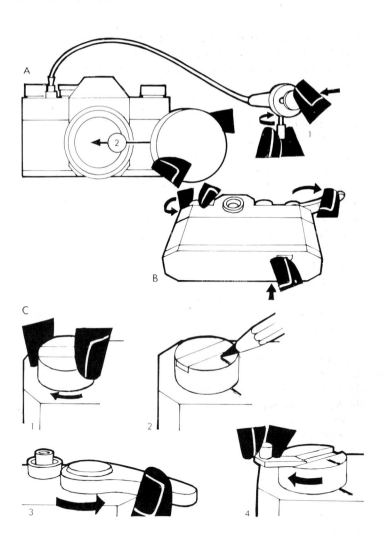

Overcoming double-exposure prevention device: A, Open shutter on B with locking cable release and use lens cap in place of shutter. B, Press in rewind button and cock shutter while holding rewind knob. C, Take up slack in film (1), mark rewind knob and camera body (2), transport film after first exposure (3), rewind film until marks coincide (4).

6 The camera is ready for the second exposure
7 For further exposures repeat film transport and rewinding

With this rewinding method, however, you will hardly be able to superimpose the various exposures on the same piece of film with the same accuracy as with the other methods.
The use of a special method of multiple exposures, for which some cartridge cameras are suitable, is not always possible:

1 Make first exposure,
2 Remove cartridge in complete darkness,
3 Wind camera shutter,
4 Replace cartridge in camera, again in complete darkness,
5 Make second exposure.

Rapid cameras, if they include a B-setting, permit double exposures only via the long-time setting. The same applies to most rollfilm cameras.
The Hasselblad and Rollei SL 66 are exceptions. The film transport crank handle of the SLR 6 × 6 Rollei incorporates a button. You must press this if you want to wind the shutter and release the double exposure lock when cranking the handle, but do not want the film wound on.
In the Hasselblad I remove the magazine after the first exposure and let its counting mechanism return to "1". I then wind the shutter, replace the magazine and am ready for the second exposure. Obviously this throws the counting mechanism out of gear; but in the non-automatic 12-exposure magazines the film window indicates the film reserve.
Naturally, double and multiple exposures are particularly interesting on colour reversal film. After all, individual negatives can be combined in the darkroom for multiple compositions.

Multiple exposures of same subject

For this type of picture it is best to keep the background jet black (velvet curtain, night sky). The aim is to photograph the object several times in front of this background. The utmost care must

be taken to prevent the various figures from overlapping. This is quite easy if you imagine the viewfinder field divided into several sections. If you change the focal length or the camera distance you can obtain both mini- and maxi-representations of your object in the same picture.

Such photographs usually appear convincing only if each of their exposures has been the same, or almost the same.

Obviously each exposure must be based exactly on the exposure meter reading or the guide number recommendation.

You can also take photographs of parts of objects "freely suspended in mid-air." I have, for instance, accommodated a model's head, differently lit as well as "painted" with light of different colours, three times on a single transparency. To make sure that only the young lady's head appeared I tied a black velvet bib around her neck. The black material does not show up in the picture if the illumination consists of indirect frontal, or even slightly lateral light. With glancing and especially contre-jour light, a little of this is reflected in the direction of the lens. As a result, a weak, fortunately very weak, light fringe surrounding the black cloth can usually be detected in the photograph.

Multiple exposure for repetitive patterns

The problem is how to photograph an object, which has to be perfectly stationary, several times in a row in front of a dark background. To achieve this the camera must be either panned step by step (p 44) or, if it has movements, the cross-front used.

The object, especially with a large number of part-exposures, becomes the basis of a decorative pattern. There is no reason why the individual exposures should not be made through different filters. If the patterns overlap – which will happen often, especially with frontal lighting – the exposure must be reduced to about one-half to three quarters of the measured value.

Lateral contre-jour lighting produces light rims on one side of the figure. Because this avoids overlapping, the exposure must conform to the meter reading.

Here is a special tip for composition: use frontal lighting for your first exposure, one-sided rim lighting for all the others.

Multiple exposure for ghost images

This is the most frequent method of multiple exposure; it is also the one that most frequently fails.

Several subjects – or a single subject, which must, however, be approached differently each time – are photographed in succession without regard to overlapping. The result: the overlapping parts of the picture seem to be diaphanous.

The "ghosted photographs" are a special case: here a picture of the outward appearance of an object and one of its "innards" are photographed on top of each other in precise register so that the outer cover appears to be transparent.

Examples of such combinations are a telescope photographed together with its own longitudinal section, a box of chocolates superimposed in the open and closed positions, and an attractive nude together with a skeleton. Certain zoom effect shots (p 70) and experiments with focus displacement (p 30) are strictly multiple exposures for ghost images, although the overlapping effect does not always strike the eye at first glance. To avoid overexposure keep the various exposures as short as possible. The following rule of thumb should be observed. With overlapping double exposures expose for rather more than the normal time. With triple exposures with triple overlap expose for rather more than one-third of the normal time. With quadruple exposures with quadruple overlap, expose for rather more than one quarter of the normal time.

Double exposure for texture montage

I consider the texture montage method an interesting variant of the ghost image method. A comparatively straightforward object (portrait, flower, vase) is photographed in front of a dark background. A suitable texture is chosen for the second exposure: a piece of masonry, grained wood, a flower bed, close-up of the ribs of a leaf, soap lather, or cracks in a coat of varnish. Contrejour pictures, too, can be combined with textures.

In both cases increase your exposure time to 1. 5x to 1. 75x normal.

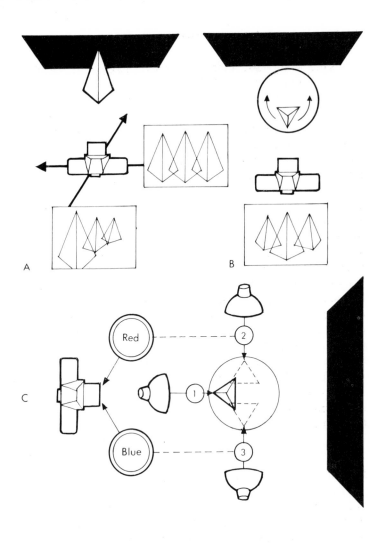

Multiple exposures. The same object can be photographed many times against a black background. A, Moving the camera between exposures. B, Moving the subject by means of a turntable. C, Using white light for one exposure (1), red light for the second (2) and blue light for the third (3). The coloured light exposures are with rim lighting.

Double exposure for texture cutouts

I produce silhouettes with coloured textures either in my dark-room, or by means of double exposures. First I photograph a dark object as a silhouette in front of a bright, as well as brightly lit, background (p 41). For the second exposure I again use some kind of texture. This is all. But it is essential to expose both part-pictures precisely in accordance with the meter reading to avoid failure.

Multiple exposures with masks

The idea of having a double has always fascinated people. A simple method of achieving your own double on film has come from the film studios. All it needs is a dark mask a short distance in front of the camera lens. With double exposures it blocks, for instance, alternately the left and the right or the upper and the lower half of the picture area. Mostly a blackened sheet of metal or a piece of black cardboard is used for this purpose. Polarizing filters, too, lend themselves for this trick; further details about it are given on p 24.

A bellows lens hood is warmly recommended as a holder for such a mask or masks. It is a superior version of lens hood. Some bellows units for near-focusing work are fitted with such a gadget. Few bellows lens hoods are designed for use other than together with a bellows unit. If you are the lucky owner of such a lens hood one can only hope that it is completely rigid. The slightest breeze disturbing its setting will make it totally unsuitable for masking. You might care to know that quite a number of excellent, sturdy bellows lens hoods are available for 16 mm cine cameras. With a few tricks they can be quite well adapted for use on still cameras. Unfortunately they are quite expensive. Building your own bellows lens hood is decidedly cheaper.

Here is a very simple solution: attach a metal funnel to a filter ring or a conventional lens hood. (We shall talk about dimensions later). Its wide opening is closed with a metal plate with a square hole. Above and below it is a guide rail each for the metal or cardboard masks. On the whole this funnel device is quite practical,

but unfortunately not suitable for the masking method with polarizing filters to be discussed later. The following setup is more useful in this respect.

A metal frame for the masks is vertically mounted at the end of a long rail. The other end has to be attached to the camera by means of a tripod screw. A sleeve made of light-proof black material elasticated at both ends surrounds the space between the frame and the camera lens to prevent light from reaching the side of the mask facing the lens; this would cause reflections that adversely affect the picture quality.

With this solution the somewhat unreliable tripod screw attachment can cause difficulties. I have therefore not made use of any of the possibilities described here. The nature of my own photographic equipment suggested another solution. In the hope that you will be able to knock something similar together from your own bits and pieces that have accumulated during your photographic practice I want to tell you something about it.

I have an old near-focusing device (for reproduction scales 1:1 to 1:3) which I use with my Leica M3. It is a table stand with a vertical extensible column. Its foot has been designed as a frame for the picture area, and is now used as a holder for the masks. A carrier arm with an intermediate ring is mounted on top of the column. The camera body is attached to one, and a camera lens to the other side of the ring. Here, too, the black light-proof sleeve is indispensable. I did not fix guide strips on the frame. In practice I use the polarized-light method; but for some experiments it is enough to attach cardboard masks temporarily with adhesive strips.

The boundary of the masked field must not be too sharp, to avoid the appearance of distinct dividing lines. But the risk that the margins will blur too much producing broad overlapping zones is much greater. Now the sharpness or unsharpness of the mask boundaries depends on the distance setting of the lens, the lens stop used, and the ratio of the focal length to the distance between the lens and the frame. You will therefore find it quite useful to be able to vary the distance between the frame and the camera lens to some extent. Generally it will be very favourable at about twice the focal length of the lens and at medium to small lens stops. This distance offers a framed field of at least twice the lin-

ear format size, i. e. about 4.8 × 7.2 cm for 35 mm, about 12 × 12 cm for 6 × 6 cm.

In theory a single piece of metal or cardboard is adequate for double exposures. But two such pieces are better: one is removed after the second has been placed in an edge-to-edge position with it. If necessary, you can also produce 3, 4, 5, indeed 20 single exposure strips in a 35 mm frame.

Multiple exposures with polarized light

The idea of using polarizing filters for masking purposes sprang from polarizing spectacles for stereo viewing. If you are familiar with the physics of polarization you will know that two polarizing filters held one behind the other will in a certain position transmit almost all the light, but block it completely after one of the filters has been rotated through 90°. Obviously, then, polarizing filters can be used for masking.

We need the following items for this method:

1 A simple camera polarizing filter. This is mounted on the camera lens so that it can be rotated.

2 A polarizing filter measuring at least 8 × 8 cm (35 mm) or 13 × 13 cm (6 × 6)

3 A circularly polarizing filter, which takes over the function of the mask.

The large polarizing filter is fixed on the frame of a bellows lens hood or of one of the home-made gadgets just described. The circularly polarizing filter, which can be trimmed in any desired shape, must be placed directly in front of the polarizing filter facing the camera lens. It must now be rotated so that it appears light when viewed through the camera polarizing filter when the surrounding field appears dark, and dark when this is lit up brightly. You may not be succesful at your first attempt. Simply turn the circularly polarizing filter.

Although I greatly prefer the masking method with polarizing filters, I do not want to conceal its disadvantages. There are three fairly substantial ones:

1 Only double exposures (triple exposures with the help of a trick) are possible.

2 The filters absorb light – to the extent of two lens stops at the light position of the polarizing filters. At the same position the circularly polarizing filter has the effect of four lens stops (through-the-lens metering is often impossible). In many cameras employing this method the tapped rays used for the measurement are themselves partially polarized. This leads to completely wrong measuring results, which often depend on the rotation position of the filter combination. Measuring differences of 100 per cent are not uncommon.

3 The circularly polarized filter is not completely colourless in the light position. It has a very slightly blue tinge.

These disadvantages compared with the metal masks are, however, compensated by three advantages, and very weighty ones at that.

The method is very rapid and simple. Between the two part exposures the polarizing filter in front of the camera lens must be rotated through 90° (This can be done without difficulty if the space between frame and camera lens is kept dark, not by means of a rigid tube, but of a dark sleeve).

The alternative masking of the various parts of the picture is extremely precise (but here, too, a distance between the front lens and the frame of double the focal length of the lens and considerable stopping down is urgently recommended).

The circularly polarizing filter can be cut to any desired shape. It is true that the individual pictures obtained with metal or cardboard masks are by no means confined to the form of strips. But complicated forms call for the cutting of two masks, which must be a precise fit and arranged accurately in the holding frame. Occasionally this can become very complicated indeed.

The following patterns for circularly polarizing filters are some of the many you might find useful: stars, polygons, circles, spirals, as well as escutcheons and outlines of key holes.

If the figure protrudes beyond the field of view in two places, the field will be divided into three parts. This makes triple exposure possible. For if the circularly polarizing filter is in the dark position, one of the two remaining parts of the picture can be alter-

nately covered – simply by hand if necessary. It is in any case an advantage if the circularly polarizing filters protrude beyond the boundary of the field of view, because they can then be attached more securely to the first polarizing filter, e. g. with clothes pegs or adhesive. But if you insist on a masking figure freely suspended in the field of view, you should choose an 8 × 8 cm (35 mm) or 13 × 13 cm (6 × 6 cm) circularly polarizing filter, and cut the required figure from it as a negative shape.

Let me briefly summarize what you can do with double exposures and masking with metal shapes or polarizing filters:

1 Photographs of doubles: the same person appears twice or several times in front of a background of concrete features. Here the camera must not be moved between exposures.

2 Photographs of ghost doubles: a person appears once real and once diaphanous in front of a background of concrete features (the masked part must be exposed twice, once with and once without the sitter. Both exposures should therefore be kept rather short).

3 Pattern-creating multiple exposures: the same subject, with minor variations if desired, is arranged repetitively to form a row in the picture.

4 Fantasy montage: related or unrelated subjects are exposed higgledy-piggledy side by side or superimposed.

5 Picturesque composition with isolated object details: details, such as the upper body, freely suspended in the centre of a picture, suddenly break off or grow from some unrelated object, e. g. from a flower or a glass.

6 Deformations: various details of an object reproduced at widely differing reproduction scales – architectural features or parts of the body – are joined to each other at weird angles.

(The types of montage listed under 4, 5 and 6 could be called collages of real objects).

7 Circling round an object: an object is photographed from the front, the sides and the rear and combined in a single picture.

Fun and games with the camera shutter

You can skip this section if you work with a between-lens shutter camera. Alienation for photographic tricks is possible with fo-

26

cal-plane shutters only. One could imagine three special creative
possibilities: one a little doubtful, two really worth while:

1 Distortion of a fast-moving subject
2 Reproduction of several phases of a rapid movement in a pic-
ture with the aid of mirrors,
3 Partial illumination of the picture area with electronic flash.

Let us start with the "doubtful" trick No. 1:
Focal-plane shutters sometimes distort fast-moving objects –
racing cars, aeroplanes – usually squashing or stretching them in
the picture. In theory the Leica or the Leicaflex would "stretch"
a Pullman train if it moved at speed from left to right and squash
it if it moved from right to left.
I said "in theory" for a sound reason. Such distortions do occur
by chance occasionally – but only rarely. The method most com-
monly used today consists in following the moving object with
the camera. This, however, suppresses such object-deformation
with absolute certainty. But even my deliberate attempts with the
Leica and the Leicaflex to obtain focal-plane-shutter distortion
did not at the beginning produce results that struck the eye. (The
situation was more auspicious with the panoramic camera de-
scribed on p 85. Its focal-plane shutter moves extremely slowly.)
If you want to go into the subject of focal-plane-shutter distortion
in a little more detail, you will perhaps find the following trick
quite useful.
Your success will be most assured if you swing your camera
round quickly in the opposite direction of the object movement.
You must, as it were, "follow negatively" with your camera –
which is not at all easy, if only for psychological reasons. You can
obtain far more impressive distortions much more easily with
much simpler means, such as an anamorphic lens (p 106) or by
copying bent originals (p 125).

Separating mirror images

Trick no. 2 is, in any case, much more interesting. Here the prob-
lem consists of accommodating several mirror images of a fast-

moving object side by side on a single piece of film. The slit rushing across in front of the film ensures that the first, then the second, and successive pictures, if any, are recorded on the film one after the other. Thus the first mirror image will reach the film a little earlier than the second, which in turn slightly precedes the third. The whole picture thus shows the multiplied object at various stages of its movement.

Obviously this trick offers itself both for aesthetic compositions and for technological and scientific analyses. Some tests will show whether this is a practical proposition. Arrange two hand mirrors closely enough in front of the lens of a Leicaflex so that each of them fills about half the picture area. Join the mirrors with adhesive strips to serve as hinges. Let each mirror reflect the image of a whirring electric fan, set up at one side behind the camera, in the direction of the lens. Expose for $1/500$ sec. The negative will show two fans, with their wings clearly in different positions. Another double-mirror test: wave your hand rapidly in front of an orange. The result: in one part-picture about three quarters, in the other only a third of the orange will be covered by your hand. If you photograph the rapid movements with a Leica M3 instead of a Leicaflex, the differences between the various phases will appear twice as marked, for the time required by the slit in the focal-plane-shutter to move across the piece of film to be exposed is twice as long in the M3 as in its single-lens reflex counterpart. (The panoramic camera (p 85) produces even greater differences.) The phase differences depend on the time required by the slit to move, on the distance between the reflected objects in the picture field (and thus also on the number of reflections), and on the shutter speed. The more reflections to be photographed, the higher the required shutter speed.

The last values of the table on page 29 are a concession to theory: I very much doubt the possibility of accommodating 16 mirror images of an object in a single picture area.

For the multi-phase trick focal-plane cameras with horizontal shutter movements are particularly suitable. When the shutter moves vertically either the camera must be set up in the position for upright pictures, or the mirrors arranged one above the other. Hand mirrors are of course adequate for ordinary purposes. If you aspire to higher quality in your pictures, you must use surface-

SHUTTER SPEEDS FOR MULTIPLE MIRROR REFLECTIONS

Number of reflections to be photographed	Slowest possible shutter speeds	
	Leica	Leicaflex
2	$1/125$	$1/200$
4	$1/250$	$1/500$
8	$1/500$	$1/1000$
16	$1/1000$	$1/2000$

silvered mirrors. These are, unfortunately, very susceptible to scratches; besides they are not exactly cheap (p 117).

Flash and the focal plane shutter

The third trick takes advantage of the well-known fact that an electronic flash when used with a focal-plane shutter at too high a shutter speed exposes, if at all, only part of the film frame. Most focal-plane shutters permit speeds of up to $1/25 - 1/30$ sec, others $1/50$ sec, and yet others $1/100$ sec with electronic flash. Now it may be my intention occasionally to let the flash act only on part of the picture.

In an outdoor shot, for instance, the entire subject is shown illuminated by daylight, but only half or a quarter of it by flash. Similar experiments are possible with combined electronic flash and flashbulb (PF 1B, AG 3B, PFC 4) illumination. Particularly intriguing: use various colour filters in front of the flash lamps.

Obviously I cannot give you detailed information about the enormous range of focal-plane-shutter cameras on the market; but if I describe the conditions with my own equipment, you will certainly find it easy to draw your own conclusions concerning your own camera. Here the Ultrablitz luminous foil will be of great help. This is how you use it: place the foil on the film guide. Remove the lens from the camera. Place the flash lamp against the lens socket and trigger it via the shutter. The illuminated part of the film frame appears as a rectangle emitting green light.

When an electronic flash unit (non-automatic or with the automatic operation switched off) is connected to the X-contact (flash

symbol) of any Leica M the right-hand portion of the film frame will be exposed at $^1/_{125}$ sec, ranging between $^1/_3$ and $^2/_3$ of the entire frame depending on the circumstances.

In my experience, sometimes more, sometimes less than $^1/_2$ frame (righthand portion) (width 16 – 20 mm) is exposed in the Leicaflex at $^1/_{125}$ sec through the X contact. $^1/_{500}$ sec will still expose the extreme righthand quarter.

I regret I cannot give you any more precise data, because the size of the illuminated picture area depends on the duration of the flash. Different types of electronic flash units have also different flash durations.

A factor of uncertainty which must not be underestimated is the state of charge of the flash capacitor. My test table tells you more than lengthy explanations.

FLASH DURATION AND CAPACITOR CHARGE

Recycling time of the flash capacitor (sec)	Length of the illuminated picture portion M Leicaflex SL $^1/_{250}$ sec X contact (mm)
4	15
10	19
35	20

To avoid a great variation of sizes of the illuminated field from picture to picture the flash capacitor should always be given ample time to recycle.

Unsharpness – a new visual experience

Within the last few years the defenders of photographic sharpness and the protagonists of unsharpness have fought bitter verbal battles. At times unsharpness produced by completely arbitrary focusing but also movement blur was regarded as the ne-plus-ultra of modern creative camera work, according to the formula: unsharp = modern = good. The fact that the = sign in this formula is based on a rash assumption and ought to be replaced by the more cautious "possibly" was overlooked by many

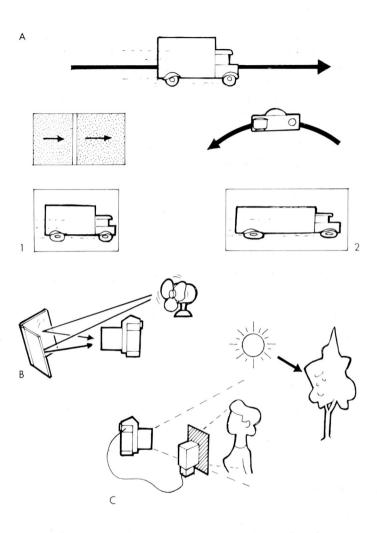

A, Focal plane shutter distortion (1), causing elongation of moving objects is not often encountered in practice. You can imitate it (2) by panning the camera against the direction of movement. B, Fast exposures of moving subject reflections show two pictures in different stages of movement. C, You can take advantage of the focal plane shutter's inability to expose the whole image area to light from an electronic flash unit. Place the model in the part the flash reaches and leave daylight to illuminate the rest.

31

a "with-it" photographer in his first flush of excitement. Many liberties were taken with unsharpness.

It cannot be denied on the other hand that unsharpness in the photograph produced by focusing (or non-focusing) represents a completely new because totally unaccustomed visual experience for those of normal eyesight. You cannot force your eye to see, for instance, a landscape unsharp. You may succeed in this with small objects when you move them close to your eyes. But if you hold your ballpoint pen about an inch in front of one of your eyes, it will cause you considerable discomfort.

Here is another experiment: walk to the window and look outside through the lattice work of the net curtains. One would have thought that the eye will see the buildings out there unsharp if it is focused on the net pattern in the foreground, if, as the experts say, it accommodates itself to the foreground. In exactly the same way it ought to see the net structures unsharp if it is accommodated to the buildings.

In reality you succeed only after great efforts in noticing at all the presence of such an unsharp background or foreground. Normally, unless you force yourself to pay special attention, nothing the eye is not sighting sharply at a particular moment seems to exist. This proves two facts:

The human eye on the one hand, and the eye of the camera on the other record two quite different pictorial impressions of a given subject.

Although it may sound odd, we perceive by no means everything we see. Our brain acts as a kind of filter, which transmits to our consciousness only what it chooses to transmit. Quite obviously unsharp information is something this filter refuses to transmit; it suppresses it completely.

There is really only one proper method of perceiving something that is unsharp: to photograph a subject unsharp, and to view the unsharp picture with a sharply focused eye.

But perhaps you feel the same way about it as I do: if you see a picture that is completely out of focus you will be vaguely disturbed. Your eye obviously finds it difficult to focus on the picture plane unless it can see at least a tiny detail that appears sharp and can serve it as a bearing. If totally unsharp pictures are to appeal to the viewers, we must give them a hint of sharpness.

Choosing suitable subjects

Not every subject is suitable for an out-of-focus picture. Objects poor in contrast or consisting of small detail will disappoint you without fail if you photograph them at a totally wrong distance setting of your lens.

Contrast simulates sharpness. As an experiment two photographs of the same subject, one pinsharp, but enlarged on soft paper, the other rather unsharp, but processed for harsh contrast, were submitted for assessment to a large number of persons. Every single judge without exception quite spontaneously thought that the contrasty photograph was the sharper one.

Dark subjects – silhouettes or near-silhouettes in front of a radiantly bright background – are thus ideal out-of-focus subjects. Contre-jour subjects are also suitable for this treatment.

If the lens – of long focal length, if possible, and with diaphragm wide open – is focused on a distance that is radically different from the true object distance, all dark figures will be surrounded by a grey, translucent fringe. In colour photographs this fringe assumes the colour of the background, which, to increase the attraction of the picture, may be completely bleached. But light sources in dark surroundings – the sun's disc in an unsharp landscape, a candle flame above an unsharp candlestick – give the impression in the picture of being completely sharp. After all, the contrast of luminous densities along the edges of the unsharp feature is great enough for the outline of the light source to be rendered as if it had been stamped out of the picture instead of in continuous tone. (Naturally this has nothing to do with faithful rendering)

There is, by the way, a simple explanation why our contrasty silhouettes and contre-jour subjects fascinate our eye by a certain illusion of sharpness although they had been photographed out of focus: no blurred details occur in black or in white areas. Such portions, unlike grey portions, will therefore always give an impression of sufficient sharpness.

To prove my point I conducted several experiments. You will find the result of one of them, a black-and-white out-of-focus picture, in this book. The data: girl in an open door at a camera distance of 6 m (20 ft). Lens focused at 80 cm (32 in), f 2. Whereas this pho-

tograph appeals to me, the companion photograph, not shown here, makes no impact at all, although, or better just because, I lit it with flash. The flash softens the black so that it is a detail-rich grey, thereby degrading the picture, which is now merely a bad unsharp photograph.

In a colour shot, the role of black in creating the illusion of sharpness can be taken over by detailless areas of uniform saturated colours.

Methods of disguising unsharpness

Unsharp, contrasty black-and-white pictures can be quite effectively "sharpened up". To achieve this, the grey fringes around the dark figures must be "planed off". If unsharpness is slight, such maltreated photographs with black figures look like ordinary sharp ones. The outlines appear merely more or less simplified. But extremely out-of-focus shapes acquire a truly fantastic character when they are sharpened. Farmer's Reducer is a very suitable means to this end.

This is briefly how it is done: immerse the generously exposed enlargement in Farmer's Reducer after fixing until the outlines appear as if they had been stamped out of the picture. Sometimes you need work only on the outlines and light grey portions with a piece of cotton wool soaked in reducer. Give the print a short rinse after reduction and fix it again; finish the treatment with the usual final rinse.

A more elegant and reliable method is repeated copying of a picture on contrasty process material.

The most convenient procedure: take your out-of-focus subjects on contrasty document-copying film (for further details see p . . .). This produces such hard negatives that simple enlargement on extra-hard material will do away with any grey fringes.

Process screens have the effect of making unsharp pictures sharp. Because the foil itself is sharp, your eye will see it as the main feature, which blocks out any unsharpness.

Colour transparencies lend themselves readily to sandwiching with process screens (p 122). Negatives should be screened during enlarging. Usually the foils are placed directly on the bromide

paper. If necessary, thin fabric, wire gauze, or similar materials can take over the function of the process screen.

Unsharp negatives on fast film even have their own kind of "built-in" screen. By exaggerated enlargement of small portions on hard paper we can bring out a sharp grain structure.

But this already belongs to the field of darkroom practice, which is beyond the scope of this book. As a matter of interest you can incorporate a sharp structure in your picture at the exposure stage. By photographing, for instance, blurred shapes through a sharply focused pane of cathedral glass we apply the same principle of composition as to the unsharp subject we "sharpen" during enlargement through a screen.

Unsharpness to suppress detail

One cannot avoid the suspicion that the out-of-focus picture fundamentally contradicts the essence of photography. Photography in the last resort has the important task of storing and communicating information. For this purpose it is indeed eminently suitable. But if we take an unsharp picture of a subject we necessarily reduce the information content the camera is capable of processing. Could this really be the object of photography? Fortunately there are three weighty arguments in favour of the out-of-focus techniques.

Today it is important not only that a photograph should present as much information as possible, but also that this information can be absorbed by the viewer within a comparatively short time. The more information a picture contains, the longer it has to be viewed. The removal of a certain excess of information can therefore very effectively contribute to a considerable speed-up in the communication of what remains.

Unusual methods of representation including simplification will induce many, initially perhaps indifferent, viewers to accept the offered information they might well have ignored in a conventionally conceived picture.

Reduction of its content generalizes the information; it also extends its validity. If a sharp picture tells us that Mrs X really exists, she will, beyond a certain degree of unsharpness, be reduced to

a symbol of Woman; when unsharpness is further increased she will come to represent Mankind. Such generalizing representation, however, is capable of stirring the imagination. Any gaps left by the eliminated items of information will be filled by the viewer's own mental imagery: the more vague the pattern reproduced the greater the latitude for the imagination to fall back on memories with which to adorn the picture.

Simplification must not be carried too far. A meaningful representation must be based on a balance between sufficient information and sufficient latitude for our imagination to function in. I regard it as a basic law of creative composition that neither must information be suppressed by the appeal to the imagination nor the appeal to the imagination by too much information.

Concerning the photographic composition I would be inclined to suggest that at least a trace of object resemblance should be preserved, because chemical and physical picture storage methods which we can classify under the general term of photography are more than any other means of representation expected to render the object faithfully. After all, the existence of an object as an original is essential to the functioning of these methods.

If we photograph an object at a large aperture and focus on a detail, letting everything else become totally blurred, we also have a good chance to obtain a picture with a good balance of information content and appeal to the imagination. The information is supplied through the sharp detail in a concentrated form. Because the surroundings are unsharp our attention is necessarily concentrated on the in-focus detail. In sharp surroundings we would hardly notice if not completely ignore it. At the same time the unsharpness of the surroundings is an ideal stimulus for our imagination. If we see a ship we have never seen before sharply focused in the background of a picture we will form no special relationship to it; out of focus, it might conceivably remind us of the one in which we enjoyed a pleasurable cruise.

Acceptable areas of unsharpness

In the past the only picture area allowed to be unsharp was the background. The foreground was, as a matter of principle, ex-

pected to be pinsharp. When colour photography arrived on the scene, people strangely enough went so far as to claim that colour pictures would be effective only if they rendered the depth of space sharp from front to rear.

Today we also accept pictures with a sharp background and a blurred foreground. Even a sharp middle distance embedded in a gradually blurring fore- and background is tolerable. Shifting the sharpness to the middle distance or to the far background can be the result of various types of approach. Two of them are of particular interest.

Details that disturb or detract from the main subject are obscured by unsharp foreground objects – blades of grass, flowers, foliage, pieces of fabric, vessels.

Details in the foreground – coloured glassware, flowers, autumn leaves – add further patches of colour to the colour picture.

Unsharp foreground objects, even those that are naturally opaque, occasionally seem, unlike unsharp opaque objects in the background, transparent. At least they are fringed by a transparent to translucent border, as already described in the context of out-of-focus photography. This seeming transparence will be all the more prominent:

1 The larger the lens stop used
2 The longer the focal length of the camera lens
3 The shorter the distance between unsharp foreground object and camera lens
4 The further the distance focused on moves towards infinity from the actual camera distance of the foreground object
5 The brighter the sharply rendered object details that are partially obscured by the unsharp foreground.

Normally a thin object – about as thin as a twig, for instance – can be shown as if completely translucent. But if it is as thick as a tree trunk it will at best be outlined with translucent fringes in the picture.

When sharply rendered light points and bands such as street lighting at dusk or reflections of the sun on water cut into those transitional zones they produce an attractive effect. For such subjects I like to use contrasty special films such as document-

copying (p 122) or infra-red (p 146) material. Here we can make the translucent figures or fringes appear dark and even black. Which does not prevent the bright bands of light from penetrating these dark shapes, achieving a most peculiar effect.

We must also mention that simple meniscus lenses from 500 mm focal length (2 dioptres) onwards are occasionally used as camera lenses, especially in colour photography with large-format cameras. Their main effect is a comparatively sharp centre and unsharp marginal zones with colour fringes. For out-of-focus photography even meniscus lenses of considerably shorter focal lengths are suitable.

Light bubbles and light stars

Tiny points of light – far distant lanterns, reflections of the sun on water, flash highlights on crumpled silver foil or in brandy glasses – become large light bubbles when photographed in out-of-focus fashion. They are nothing but images of the lens diaphragm.

The light bubbles are the larger:

1 The more out-of-focus the lens setting
2 The wider the lens aperture
3 The longer the focal length of the lens used.

However, the brightness of the light patches decreases as their size increases – similar to the colour saturation of a toy balloon. It may therefore be useful on occasion to reduce the size of these patches slightly by means of stopping down a little – especially when the original highlights are not particularly bright.

In the mirror reflex viewfinder, shape, size and brightness of the bubbles can usually be readily observed; but certain special focusing screens alter them in a strange fashion. I am thinking in particular of the microprism screen designed for highly critical focusing. It changes the patches into stars.

All this need not discourage you – you will find your circles again, round, well-shaped and perfect, in your final photograph.

Concerning perfect circles: clean, sharp bubbles depend on tiny

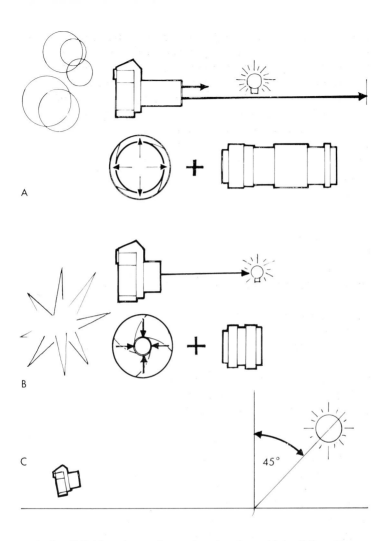

A, Small light spots can be rendered as large blobs if they are considerably out of focus. They are larger at wider apertures and with longer-focal-length lenses. B, The diaphragm edges sometimes cause very small light sources to be reproduced as stars. This usually needs accurate focusing with a short-focal-length lens. C, The sun at 45° azimuth can sometimes be reproduced as a star shape.

lights and reflections. The decisive factor is the apparent minuteness of the light points.

I have recently carried out an experiment to prove it:

I arranged three burning candles and about 10 silver foils of used PFC-4 flash cubes spread out on a mirror to double the number of lights in the picture. I illuminated the whole set-up with a 1000 W halogen lamp through a blue filter. The lamp was reflected as tiny points of light by all the mini-reflectors impressed in the silver foils. In the out-of-focus artificial light transparency the highlights produced blue, sharp circles that might have been drawn with a pair of compasses. The orange-coloured, slightly blurred images of the flames resembling cones rather than circles, stood out clearly against these highlights.

Pattern effect pictures produced with the same set-up reveal such differences even more strikingly.

Light bubbles in colour have a special appeal. All you have to do is illuminate glassware, metal, or other shiny objects with colour-filtered small light sources from the greatest possible distance. The use of flashbulbs is most successful here.

Light bubbles will of course appear not only in typical out-of-focus pictures. In fact they look particularly effective in association with sharp details. You can produce fantastic pictures above all when an object in the far background on which the lens is focused is partly superimposed by light bubbles conjured up in the foreground. That the subject on whose surface the light-patch-producing reflections scintillate appears mostly softened almost beyond recognition is of course obvious. But we have a remedy for this: double exposure (p 14). With the first exposure we focus on the light bubbles, with the second on the object proper. That is all!

Seemingly tiny lights do not always blow up into bubbles, occasionally they appear as stars. Responsible for this is the diffraction of the light rays on the edge of the lens diaphragm. Unlike the circular patterns, the stars will show up best when:

1 The lens is focused as accurately as possible – at least reasonable accurately – on the light source
2 The lens is stopped down to minimum aperture
3 A lens of shortest focal length is used.

Star images are formed of really tiny light points also by long-focal-length lenses. I realized this unexpectedly when I recently photographed a cube flash fired at a distance of 10 m (33 ft) with the 180 mm Elmarit-R in my Leicaflex at f 16.

If you want to show the sun as a sparkling star, you must take it at about 45° azimuth when it is still bright enough to blind the eye; use a lens of 50 mm or shorter focal length.

With a little skill and some luck you can transform small reflections on shiny objects into coloured stars quite easily. For the stars to be well formed the exposure should be short, in fact two or three stops smaller than normal may be required especially for pictures of the sun (see also the wire gauze trick on p 42).

Pattern tricks with light circles

What do you think of the idea of transforming light circles into spirals, stars, triangles or any other figure required? Difficult? Nothing could be simpler. After all, light circles are merely images of the lens diaphragm. All you have to do therefore is modify the aperture diaphragm, and the light circles will follow suit. For this purpose cut round cardboard discs, just large enough to cover a lens, and simply clamp them between the front lens and the UV absorbing filter. Cut these discs to the desired patterns or cut specially shaped holes in them. Before you expose please bear in mind that the masks hold back part of the light entering the camera lens. You must therefore increase the exposure correspondingly.

At the risk of repeating myself I must emphasize that only light points that are seemingly small, very, very small, ensure a sufficiently sharp rendering of the light patterns. By the way: the masks affect the shapes of the light circles only; any other object details, whether sharp or unsharp, in the picture remain almost completely unaffected. You can therefore readily combine in a picture a foreground decorated with patterns of light with a sharp background.

The door is wide open to fantastic experiments with colour. It is, for instance, a good idea to produce reflections of light sources of different colours on a suitable object, and to convert them into

patterns of coloured light. The object proper including the background can then be additionally lit with neutral, for instance indirect, light. Suitable conditions might suggest double and multiple exposures.

Lastly you can of course colour your light patterns also partially. I offer you a choice of four different methods:

1 A colour filter is held in front of the camera lens, to which the mask is attached so that it covers about one-third to one-half of the lens aperture. The result is that all light patterns appear partially coloured.

2 Pieces of gelatine filters of various colours are stuck over the holes in the mask. The result is an array of light patterns of different colours.

3 Double exposure: during each exposure a different filter is held in front of the lens or in front of the light sources. Furthermore, one exposure should be at full aperture and for the other the lens should be stopped down about two stops (which, naturally, means a longer exposure time). Result: the colour of the marginal zones of the light patterns differs from that of the central portions.

4 Double exposure through a polarizing mask: a polarizing filter is placed in front of the lens. A circularly polarizing filter cut to the required shape and a further polarizing filter are arranged as closely as possible in front of the first filter. (The principle of the set-up has been described in detail on p 24). Important difference in the arrangement:

The circularly polarizing as well as the second polarizing filter must be mounted directly in front of the first polarizing filter attached to the camera lens. (The less the distance between the three filters the better). Between the part-exposures the camera filter must be rotated through 90°. In addition, yet another filter of a different colour must be placed in front of the lens or the light sources each time. The result is coloured circular light patches containing patterns in different colours.

I must also mention that you can hold wire gauze or similar structures instead of your home-made masks in front of the lens to modify the shapes of your light patches. The same wire gauze at-

tachments can, if required, surround light points with halos. To achieve this effect, the lens must be critically focused on highlights against a dark background such as contre-jour reflections on the sea, city lights at night (star effect filters produce similar results).

Movement blur

"Wipe effects" or "movement tracks", I think, would be much better terms for this phenomenon. After all, "movement blur" might create the totally erroneous impression that such pictures are completely unsharp and that because everything is in any case blurred, it is unnecessary either to focus the lens accurately on the subject or to keep the camera steady. No. Let me emphasize most strongly that successful movement blur effect photographs depend on precise focusing as well as on a sturdy tripod. Only the subject is permitted to move, not the camera (with very few exceptions); the shutter speed is usually much slower than $1/30$ sec.

The movement blur effect, by the way, is not one of those methods that suddenly appeared on the scene from nowhere one fine day, henceforth to enrich the scale of possibilities of photographic expression. The recording of movement tracks has a certain tradition of its own. Early versions were minute-long exposures of the headlamp- or rearlight tracks of cars speeding along in the dusk. This was followed by illuminated merry-go-rounds on fairgrounds at night. Even today such movement sequences proceeding in predictable tracks and therefore producing photographically decorative lines and figures are among the movement blur effects that are practically always pleasing. If you want gradually to master the refinements of photographing movement tracks, why not experiment with rotating propellers, sails of windmills, moving cars and billiard balls. Remember always to take a series at several shutter speeds.

Here are two examples: between two meadows, with blades of grass standing out pinsharp in the upper and lower part of the picture, appears an express railway coach, obviously taken from a raised viewpoint with a long-focal-length lens. The long time

exposure has dissolved it into a many-banded streak of different colours.

An express train speeds through the twilight. The special pictorial accent is supplied by the blurred line of the brightly lit windows. I think the next step of movement track photography concerns movement with at least one stationary subject which in the picture is naturally reinterpreted as a resting point. Take the example of a ball being thrown right across the picture area. The long time exposure would – at best – reproduce it as a streak. If the background is too bright or the exposure too long it could disappear completely. But what happens if we let it bounce around a table top? It would create arched lines on the film. But at the culmination point of the arches of varying widths the ball would be reproduced relatively clearly, because this is the spot at which the bouncing ball remains stationary in midair for an instant, when it has finished its upward movement, and is about to fall again. All types of movement which are stopped in their course for a moment, including those that are rhythmically repeated in the same place, offer the opportunity to reproduce the moving object recognizably in the picture, singly or repeatedly, together with its movement track.

Here are a few examples of motifs: high jump, electric or diesel train briefly stopping and starting, a girl on a swing, a blacksmith wielding his hammer, a lumberjack felling a tree with an axe, a housewife flattening a steak.

Panning the camera

This leads us to the third and most advanced stage of movement blur effect photography: irregular movements, usually of people and four-legged animals. The sprinter, the horse or the hound – none of them leaves tracks as straight as cars or railway trains. The main reason for this is that some subject details – arms or legs – perform additional movements in different directions and at different energies. Typical long-time exposures of such objects lasting many seconds if not minutes are mostly rather unrewarding. On the other hand, here the method of following the subject with the camera begins to come into its own; the camera

must be taken off the tripod and raised to the eye. The subject is sighted, followed, as it were, with the camera, and the shutter released during the process.

What does the result look like?

Firstly the background will be more or less blurred. The subject we have followed appears, on the other hand, reasonably clear, although not pinsharp, in the picture. The sharpness of the moving details, however, such as the horses' or the sprinters' legs, depends to a very great extent on the shutter speed used. At $1/125$ sec and higher they will appear rather sharp, between $1/8$ and $1/15$ sec they will be attractively blurred, but from $1/4$ sec onwards the likelihood that the legs will no longer be visible in the picture will increase.

Combinations of sharp and unsharp

Within the last few years we have seen more and more stage photographs in which the blur effect is very freely used: this refers particularly to ballet groups. I have myself taken enough such pictures to be fully aware that here often, perhaps too often, a virtue is made of necessity – the blur is the inevitable result of long exposures to compensate for poor lighting. But on the other hand such performances are particularly suitable for this blur effect photography for two reasons:

1 The background is usually dark, and the blurs stand out against it clearly and in saturated colours (bright backgrounds reduce the colour brilliance).
2 At shutter speeds between 1 and $1/5$ sec some actors frequently appear blurred while others, maintaining a certain pose, are sharp.

In my view pictures depending for their impact on the contrast between sharp and unsharp details are considerably more attractive than totally blurred ones. Let me give you a few more examples to illustrate my point: I like to photograph crowds in the street from above at about 1 sec shutter speed. Since some people move fast, others stand transfixed in front of shopwindows or

are impatiently waiting for the traffic lights to change, I get almost always a mixture of sharply rendered and blurred people.

I photograph trees moving in a gale, at a long-time exposure, so that the solid trunks appear sharply outlined in the picture: the branches, writhing in the gusts of wind, look like green clouds.

A shutter speed of $^1/_5$ sec is most suitable for dissolving a piece of cloth fluttering in the breeze into a translucent coloured haze. I find this method so interesting that I occasionally use it even with attractive girls.

Blurred rapid movements of the hand pouring a glass of wine, lighting a cigarette, dealing a hand of cards, can be most effectively combined with a sharply rendered face. The blur effect can be used even to reproduce simple tools, for example a pair of pliers, in a most original manner. One half remains fixed, the other is moved rapidly during the exposure.

The main idea of all these examples is the confrontation of a sharp object (or part of an object) with an unsharp one. But I find it at least as attractive to mix one and the same object as a sharp and as a blurred feature in one and the same picture. Depending on the type of movement one obtains sharp central pictures with blurred movement fringes, or blurred movement trails.

In practice this can be achieved, as already mentioned, with certain subjects whose movement briefly stops. But a combination of long-time exposure ($^1/_2$ – 1 sec) and flash has proved much better still. I therefore like to use this method with dancers. Remember, however, that the background must be as dark as possible.

Whereas ordinary blurs can be recorded both in black-and-white and in colour, blurs with flash cry out for the use of colour. If the colours of flash and supplementary flash are different, a colour contrast will be created between the picture and the blur that will be appreciated very much.

It is, by the way, by no means essential to synchronize the flash with the camera (in which case the flash is normally fired at the beginning of the open shutter period. But in a few types of camera the flash is fired when the shutter begins to close). You can also fire the flash manually right in the middle of the open shutter period, which should be at least $^1/_2$ sec.

Exposure times from about 2 to 3 seconds even make it possible

to flash the subject from several directions with two, three, indeed four pre-arranged flashes filtered in different colours. If the experiment is successful, this produces a kind of stroboscopic effect.

MULTIPLE LIGHTING WITH DIFFERENT COLOURS

Type of film	Electronic flash or bluetinted flashbulbs	Supplementary light for long exposures	Remarks
Daylight	unfiltered or with blue filter	photofloods, halogen lamps	The blue of the unfiltered flashlight is too subdued, hence additional blue filtering is recommended
Artificial light	unfiltered	photofloods, ordinary filament lamps, or yellow Comptalux reflectors	To bring out colour differences effectively ordinary or yellow filament lamps are better suited than pure photoflood light
Artificial light	with strong red filter	blue or green Comptalux reflector	
Daylight	with strong blue or green filter	yellow or red Comptalux reflector	

Stroboscopic effects

A flashgun fires a single flash; to continue the analogy, we can explain the action of the stroboscopic flash as that of a flash machine-gun. Unpleasant though this connotation is, its only disagreeable feature is that it produces a flickering sensation in front of our eyes. Strobe flash is used to record several phases

of a rapid movement in a single photograph. When, however, the movement is not too rapid, we can simulate the occasionally funny stroboscopic effect comparatively simply with the aid of multiple exposures (p 19). As in all genuine and not-so-genuine stroboscopic pictures the background should be dark. Although incident light is quite suitable as illumination, contre-jour light is much better. Any part-illumination can of course be filtered in different colours. (Colour filter in front of the camera lens or the flash lamp). This will make the various movement phases contrast clearly and at the same time attractively with one another.

The slotted wheel brings us a step nearer to the genuine stroboscopic picture. My first experiment was an attempt to produce a stroboscopic effect by photographing the ball bouncing off a table covered with black velvet, and already used as a track-forming object (p 58) together with a simple three-blade table fan. For this purpose I arranged the camera directly behind the fan, so that the lens was alternately blocked and unblocked by the fan blades. The result was disappointing. All I obtained was a blurred track. True, slight shadows revealed the movement phases at which the "lens wipers" flitted across the camera lens. To bring the structure out correctly, however, I ought to have used document copying film (p 122). For some exposures of this first black-and-white test film I had moved the wheel only by hand so that it rotated quite slowly. This gave me two to three wide gaps in the blur line, that was all. I now made a disc of black cardboard and mounted it above the blades with adhesive tape. The radius must not be much larger than the length of the fan blades to eliminate difficulties concerning the rotation. I cut a wedge-shaped sector of not quite 3 cm width from the rim. Near the centre this sector narrowed to a point. During one rotation, light now reached the lens only once. The dark phase was about 20 times longer than the light phase.

This arrangement proved to be very successful indeed. Between 8 and 12 pin-sharp individual pictures of the ball were recorded on the test negative, naturally complete with the trace of its trajectory. But even here, the slow rotation did not prove successful. Mostly no more than two, and at best four, pictures were produced. Which is not quite enough.

I now played with the idea of making a two-slot-fan stroboscopic

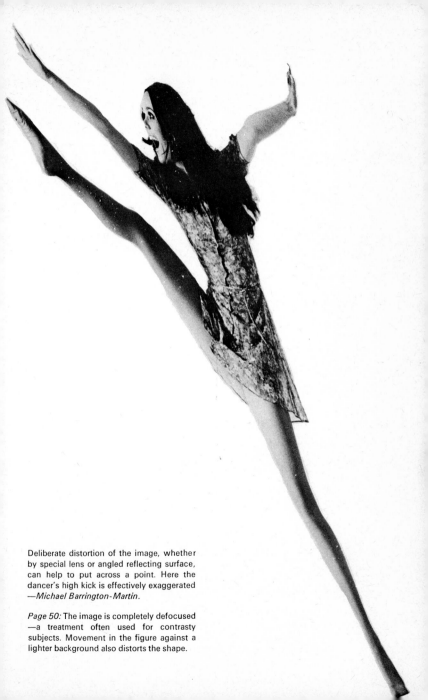

Deliberate distortion of the image, whether
by special lens or angled reflecting surface,
can help to put across a point. Here the
dancer's high kick is effectively exaggerated
—*Michael Barrington-Martin*.

Page 50: The image is completely defocused
—a treatment often used for contrasty
subjects. Movement in the figure against a
lighter background also distorts the shape.

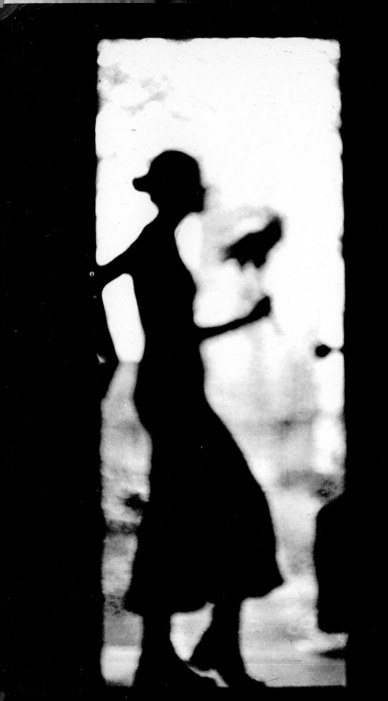

The distortion effect produced by the Iscorama anamorphic attachment. The $\frac{1}{2}$-sec exposure was assisted by flash and photo-flood. The attachment was rotated 90° during the exposure.

Page 52: A Regency silver sugar bowl photographed with a zoom lens with fixed position at minimum, and zoomed between medium and maximum focal lengths.

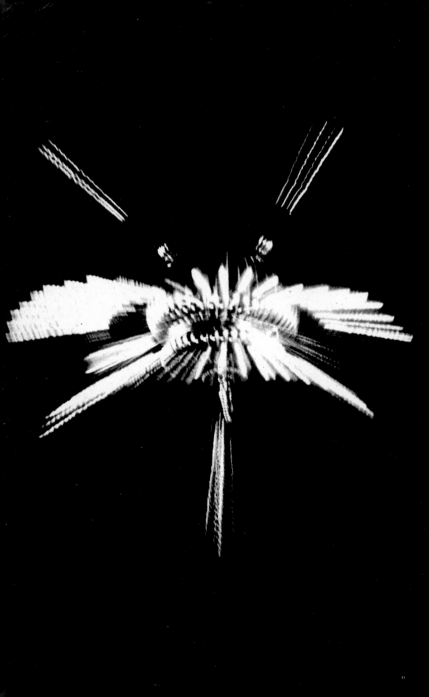

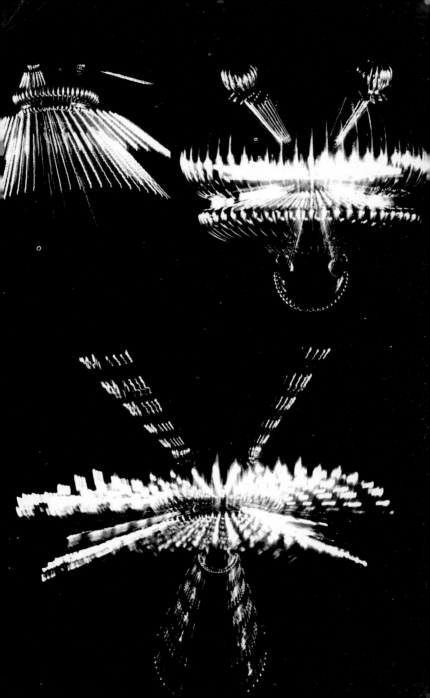

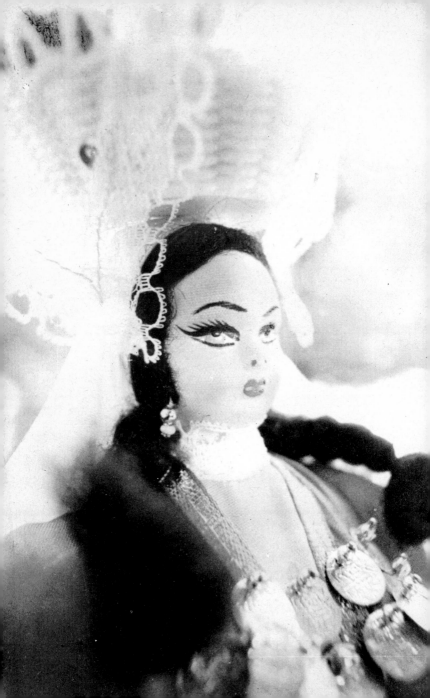

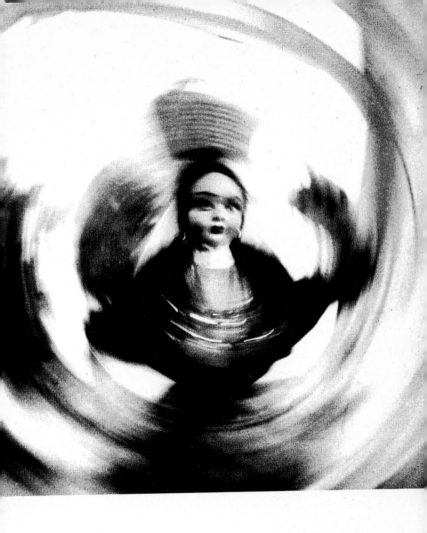

An ultra wide angle lens and 4-dioptre supplementary lens were used for the against-the-light picture of a Greek costume doll on the opposite page. The same doll provided the picture above, taken with a fish-eye lens at 1/15 sec. During the exposure the camera was rapidly rotated on the lens axis.

The fish-eye lens takes in everything in front of it and can prove a useful method of illustrating, if rather bizarrely, the entire contents of a room—*Michael Barrington-Martin*.

picture in colour, covering one sector with a red, the other with a blue filter. This would have doubled the number of pictures of the ball. 16 to 24 pictures would have been quite acceptable with this kind of subject, particularly since a blue picture would always have alternated with a red one. But I recently changed my mind. Out of a dark-blue colour effect filter (for details see the relevant table) I cut a slotted wheel, which I mounted on the fan instead of the black cardboard disc and covered the slot with a bright orange gelatine filter (the dark rims caused by the overlap of filters are no more disturbing than the opaque fan blades). Colour photographs of the ball taken through the rotating filter wheel now show a dark blue blurred track, combined with many sharp orange-coloured phase pictures.

The orange is rendered much better still if the slot in the blue disc is left open and a warm-coloured conversion filter placed in front of the lens and the light sources. A similar effect is obtained if the black cardboard disc is allowed to rotate in front of a warm-colour-filtered projector and the blurred track brought out by an additional blue Comptalux lamp.

I have already used the fan strobe method for sports and dance photographs with notable success.

By the way: if you know the r. p. m. value of the fan you can easily calculate the velocity of the object between the individual phases from the distance between the various pictures if you allow for the reduction ratio.

A further method for the stroboscopic recording of very rapid movements is based on several electronic flash units of short flash duration – about $1/1000$ sec or shorter, and one photo-cell firing unit less than there are flash units.

Normally with light-impulse remote-firing the first flash fires all slave flashes simultaneously via photo-cells. What we want here, however, is to utilize the very brief dark intervals between flashes for the strobe effect. We therefore must ensure that each flash causes only one other to fire.

To achieve this I had to screen the "eye" of every single firing unit with cardboard tubes and to reduce its sensitivity by means of grey filters, so that it could operate only from a flash placed very near to it. I then placed a photo-cell directly in front of each flash lamp except the last, with the result that the flashes fired con-

secutively instead of all the slave units firing together.

I must point out that the flash sequence is extremely rapid (less than $1/1000$ sec), making the method suitable only for extremely rapid movements. Differential colour filtering produces a clear separation of the individual phases in all strobe effect photographs.

Light tracks – light patterns

If a horseman wants to find out how the right flank of his steed moves during a gallop he can do so by attaching a bright electric light bulb to the flank and letting the horse gallop about in front of the camera in twilight. Pictures taken at long-time exposures will show a light track that accurately marks the movement of the horse's flank.

Flash, which reproduces individual phases of the movement, increases the clarity of such pictures still further. You might be interested to know that our comparatively simple light track method has an importance not to be underestimated in the technological or scientific analysis of movement as well as in sports photography. At the same time such pictures, if they are decorated with several, perhaps differently coloured, light lines can also have an aesthetic appeal.

Speaking about aesthetic values in connection with light tracks, I must not forget to mention the decorative pendulum photographs. For my experiments I suspended a pocket torch from a thread, length 1. 2 m (4 ft), fastened to the ceiling of a darkened room. I placed the camera on the floor at the same distance below the pocket torch, sighting the torch with the standard lens. For ultra-fast film, f 4 was most suitable for my light source, a tiny bulb diffused through a piece of flimsy paper and covered with black adhesive tape except for a small hole. When underexposed the lines become blurred, to begin with where the pendulum swung particularly fast. With overexposure halation will occur at the points of reversal and especially at track intersections. Before releasing the shutter I try to make the pendulum swing so that it describes oval figures.

After waiting a little until the pendulum has settled down to a

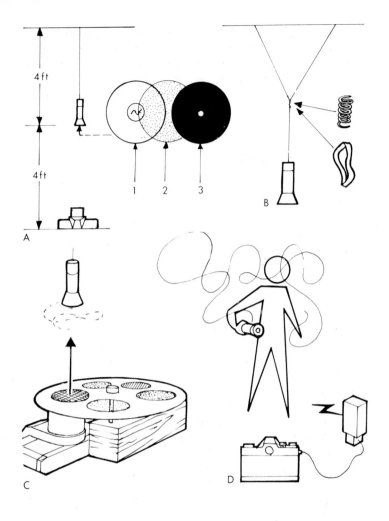

A, Forming a light track with a flashlamp suspended from a ceiling. The bulb is diffused and covered except for a tiny spot. B, Variations of pendulum swing by two-point suspension and the addition of a coiled spring or rubber band. C, Light track colours can be varied if different coloured gels are moved in front of the lens. D, After a long exposure of a moving light, the figure is exposed by flash.

regular to-and-fro movement I open the shutter. In my experience it is best to record about 10 to 20 orbits. More is too much, the figures will be too complex. A pendulum suspended in such a simple manner, however, can produce only simple track figures. More complicated patterns require more complicated suspensions. The simplest type of pendulum for such patterns is suspended doubly: two points on the ceiling, not too far apart from each other, are joined by a slack piece of thread. Another piece of thread, with the torch at the other end, is tied to some point or other on the thread. The basic shape of this pendulum can be described as a large Y. One of the three threads of this Y can be replaced by a spiral spring or a rubber ring. This produces new variations of pendulum figures. Altogether the range of possible patterns has no limits. Entire mobiles can be constructed with rods and weights. They perform fantastic motions and therefore fantastic or random, confused oscillation figures.

One can also hang a weight on a simply suspended pendulum thread. Whether this produces an ornament or the patterns in the sand of a chicken-run depends on the ratio of the distances ceiling-weight, weight-light bulb. These pendulum patterns can, by the way, be recorded with a light pointer directly on special printing paper instead of with a camera. Pendulum figures are often photographed on colour film through several different colour filters. But this either calls for a change of filter during the exposure, or two or three differently coloured pendulum figures must be recorded on the same piece of film by a multiple exposure.

I recently tried yet another method. I dipped several screw heads in red and yellow luminous paint, suspended them from various parts of the pendulum and illuminated them with four blue Comptalux reflectors. (Further details about the so-called blue-light fluorescence p 145) I thus recorded the tracks of several luminous points simultaneously on colour negative or colour reversal film at f 2. The disturbing blue light reflected by the ceiling can, if necessary, be reduced with an orange filter in front of the camera lens. But this also reduces the brightness of the luminous screw heads so much that even at full aperture a track will be produced only if the lamps are set up at very close range or a large number of blue reflectors, or a faster film and forced develop-

ment are used. An effective cure for blue reflected light is to line the ceiling with black velvet. This obviates filtering. An even better method is to use two 125 W UV lamps via two mains units, and place a yellow filter in front of the camera lens.

To complete this section, I must mention "painting with light". In a darkened room fantasy figures are drawn in the air with a pocket torch, and recorded by the camera. At the end, the "draughtsman" (or woman) is included in the picture by means of flash. For colour film the pocket torch and the flash should be behind different colour filters.

Revolving bodies

This is easily the most paradoxical chapter in this book: I am talking about two-dimensional, i. e. flat, objects which are to appear as three-dimensional, i. e. spatial, features in the two-dimensional picture by means of a photographic method.

It is true that strictly only reproduced objects are two-dimensional. Everything existing as a real object extends in space and is therefore a body. Now the bodily nature of a wire hoop or of a leaf is far less manifest than that of, say, a cube. Even a small pair of pliers, which, after all, is about 7 – 10 mm ($^{1}/_{4}$ – $^{3}/_{8}$ in) thick, can easily be regarded as a mainly two-dimensional object. But if we let it rotate, and photograph its movement at a long exposure time, it will appear in the picture as a completely three-dimensional body, that is, as a revolving body. We can mount the pliers with blackened wire on a turntable (fan, tilting unit for the Leitz Focomat for correcting converging verticals etc). Rotating chairs whose height does not change when they are being turned are also quite suitable. But I prefer to suspend my objects on a piece of thread from the ceiling, and wind the thread up; the object will rotate for quite some time whilst the thread unwinds. I can manage 3 or 4 long-time exposures before I have to rewind the thread. Sometimes the object wobbles slightly; this produces pictures with considerably softened outlines, which can look quite attractive.

A single object offers a quite unexpected variety of bizarre figures of revolution. To return to our pair of pliers: here results will be

vastly different depending on whether it is suspended length- or crosswise, straight or obliquely, open or closed.

If the object is sighted a little obliquely from above or below, very well-modelled pictures of three-dimensional appearance are obtained. But if it is sighted fairly accurately at right angles to the rotational axis, axial-symmetrical figures of comparatively flat appearance will be recorded.

I usually take my pictures on colour film, lighting the object with 2 or 3 differently colour-filtered lamps set up to give glancing or contre-jour side light. Even if the object is illuminated completely evenly, the outlines of the revolving bodies will appear considerably lighter on the slide than the bodies proper.

The reason for this is that as a result of rotation the image projected by the lens moves more slowly on the film near the margins of the figures it creates than in the centre. More light therefore collects along the margins. The centre of the figures is usually rendered translucent, so that the rear parts shine through. This enhances the illusion of three-dimensionality. With a short exposure the centre of the picture is completely suppressed – an effect that should occasionally be aimed at.

What you regard as the "correct" exposure for your revolving figures is largely left to your own judgment. As a rule of thumb, determine the correct exposure for the stationary object and increase it at least by the factor 4.

The only difficulties likely to arise concern the background. It should be kept completely dark. The best method is to mount the object on the jamb of an open door or a window frame and use the night sky as background. For my first experiment with a pair of black-varnished pliers I used a piece of black velvet suspended behind them. But the brightness difference between the pliers and background was so small that the figure in the picture is now backed by a messy, grey-blue expanse. Since one normally takes several identical pictures, this is not as bad as it seems. All you have to do is place two transparencies in precise register and mount them with adhesive tape (sandwich slides p150). This makes the background appear darker and the colour of the figure more saturated. Nevertheless I continued my experiments with a pair of pliers of silvery finish, a reduced distance between the light source and the object, and an increased distance between

the velvet and the object. I found this quite successful. Very thin objects, such as wire, are dipped in luminous paint and illuminated with blue Comptalux reflectors (blue-light fluorescence, see p 145). In my practice, I have found this method most reliable much more so that in my light pendulum experiments (p 58). Now every desired shape of revolving body can be created with a suitably bent piece of wire. But I for one prefer to play about with a real everyday object, even if it is only a picturesquely shaped clotheshanger.

Sometimes, when I see fashion models who have managed to reduce their vital statistics almost to two-dimensionality, I wonder whether making them perform pirouettes and using a long time exposure would improve the quality of their curves . . .

I often like to combine in my pictures the revolving body with the object that produced it. All I have to do to achieve this is fire a flash once or repeatedly during the rotation – of course a flash filtered in a colour different to that of the constant illumination. May I ask a pertinent question? Are those revolving bodies we see in our pictures real objects? Do they really exist or are they phantoms? What we do in fact see is a movement trace. But the rhythmical regularity of the motion creates a figure whose reality resembles that of a fountain; this, too, owes its pattern mainly to the inertia of our eye. "Pattern", of course, is the correct term for it. Don't let's call a revolving body and many other features created purely photographically "objects", but patterns, as something intangible that creates the impression as if it really existed. The next variant of revolving body creation takes us to the following sections. The movement of the camera is added to that of the object.

If we tilt the camera vertically while a preferably very simple object is rotating, the revolving body expands into an ornamental, sometimes spiral-shaped pattern. Panning the camera and photographing the object at some distance with a long-focal-length lens produces almost ribbon-shaped features. In contrast, a wide-angle lens used at a short distance produces a cylindrical distortion (p 83). The middle section of the garland seems to be bent in the direction of the lens.

Revolving bodies can be shown on the "nest-of-tables" principle if they are photographed with lenses of various focal lengths and

multiple exposures. I particularly like the possibilities of the zoom effect (further details p 68), which produces a spiral "nest".

Rotating images

Rotating images are completely different from revolving bodies. The "bodies" are created by rotating objects. To obtain rotating images, however, we have to rotate the camera, with the optical axis also functioning as the axis of rotation (it may, of course, be an advantage to place small objects on a turntable and to let this rotate instead; here the axis of rotation must be, as it were, the continuation of the optical axis of the camera).

The characteristic and striking feature of rotating images is their circular stratification. Parts of the subject situated at the centre of the circle appear comparatively sharp. The greater their distance from the centre, the more they will be dissolved in circular blurs.

It is as well to draw a clear distinction between rotating pictures of objects taken with a handheld moving camera and those with the camera on a tripod. The ball-and-socket head on the tripod can be adapted for rotating effects by means of a right-angle metal bracket with bushes for tripod screws in both limbs. Two ball-and-socket heads screwed together can also be used, but only within certain limits. The single bracket permits us to align the axis of rotation fairly accurately through the centre or through any other point of the object. (The greatest precision can be achieved with a large-format camera whose back, including the sheet film cassette, is rotatable.)

Handheld rotating exposures are of course subject to many imponderables. Surprisingly enough I am usually successful in making the centres of the circle and of the picture coincide. For pronounced blurs with a handheld camera $1/8$ to $1/15$ sec has been found most suitable. At higher shutter speeds the centre of the circle will often appear sharp and only the peripheral features slightly blurred. Here it is of course also important how quickly and through how large an angle the camera is being rotated.

Let us look at it from a purely theoretical aspect: for a required resolving power of $1/10$ mm a sufficiently sharp circle of 1 cm dia-

meter will be obtained if the camera is turned through 1° during the exposure.

ROTATION OF CAMERA AND SIZE OF CIRCLE

Diameter of sharp circle	Rotation of the camera during the exposure through
(mm)	(°)
1	10
2	5
5	2
10	1
20	$1/2$
40	$1/4$

I am quite aware of the fact that although these data illustrate the situation very clearly, they are pretty worthless in practice. If you really want to control the relationship between the sharp and the blurred portions of the picture effectively you will find it useful to adopt a certain dynamic method of rotation and always execute it as smoothly as you can.

The rotating blur causes adjacent dark and bright parts of the object to fray at the edges and to invade each other. The role of the shutter speed must not be underestimated.

Example: dark portrait in front of a bright sky. Underexposure makes the outline of the head appear larger. Darkness spreads into the neighbouring bright areas. Overexposure shrinks the head. Brightness invades the margins of the dark shape.

The particularly attractive combinations of rotating images with sharply rendered features are made possible by the already discussed methods of multiple exposure (p 19) or supplementary flash (p 46) in conjunction with differently coloured filtering. With the camera mounted on a tripod the rotary movement can of course also be delayed until after some pre-exposure.

Camera shake – intentional

Moving objects cause blur effects (p 43), which usually are found only in portions of the pictures of varying size. The moving cam-

era on the other hand, makes the entire picture appear totally blurred (exception: when the camera follows the object, p 44). We must distinguish between two types of camera following; both require a rather generous exposure:

1 Exposure from a vehicle normal to the movement direction. Here the straight-line movement of the camera has the effect of making the objects appear the more blurred the shorter their distance.
2 Following from a stationary position whether in a horizontal or a vertical direction, is always a panning movement. The extent of the blur is therefore roughly dependent on the distance between camera and object (exception: extreme close-up range). Hand-held following is worth-while only if the brightness of the subject permits a very rapid movement of the camera. Leisurely following is possible only from a tripod.

Whether or, as in most cases, not this method produces really useful results depends in the last resort on the subject. Evenly lit landscapes or detail-rich portraits are hardly suitable. Absolutely ideal for this method are simple objects, which should be as bright as possible in front of as dark as possible a background. Let me demonstrate a few rules of composition with a simple gold wire circlet. It should be placed on dark blue or dark red velvet. Camera sights the circlet obliquely from the top, panning above and across it: the picture appears tube-shaped.
Picture edge-on, so that the circlet appears as a line. Depending on the direction of the camera movement we obtain an extended line or an oblong or rhombic area.
Circlet again taken obliquely from the side, but with the camera moving in curves or loops or abruptly changing the nature of its movement: a bent, knotted, or kinked tube appears in the picture. When the speed of the camera movement is being varied bright and dark areas alternate in the recorded portions, the bright ones being due to slow movement.
The camera first remains stationary, then moves, but stops again before the end of the exposure: emphasis on the tubular shapes, since the mouths of the tube are rendered especially bright.
To sum up, suitable objects include mainly shiny and colourlit

metal objects, such as tools, but also very colourful Christmas trees, and details of brightly lit city streets and fairgrounds.

Do not carry out the movements too slowly and give very generous exposures to obtain conspicuous light tracks.

A word of warning: there is a world of difference between the well-conceived, well-composed picture taken with a moving camera, and the plain, unmistakable dud; we all make mistakes, and an author should be honest enough with himself to treat them as such.

Camera movement ("tracking") towards the subject

If you sight a subject you are approaching with your camera from a vehicle, the object will display a star-shaped blur. The centre of the picture may still be comparatively sharp, whereas the details in the peripheral positions will be totally blurred. The degree of blurring depends, among other factors, on the exposure time. If the camera moves towards small, bright close-up objects set up in front of a dark background, blurred halos surrounding them will appear in the picture.

Both effects can be produced much more clearly and effectively and at less risk of failure with a zoom lens. All that is left for me to explain to you is how to move the camera towards the object in the close-up range. The lucky owners of a tripod dolly are of course at a great advantage. But you can also mount your camera on a mini-tripod and the handlebar of a child's tricycle; mounting it on a flash rail is, however, better still: suspend the rail on two pieces of string from the ceiling like a swing. If you have a heavy lens that makes the camera front-heavy, you can fix a counterweight in the form of a second flash rail at the back. During my experiment I used an ultra-wide-angle lens at the shortest possible distance to obtain a noticeable change in the reproduction scale even by a negligible movement of the "swing".

That not only the size of the object, but also the position of its projected image on the film is changed by this swinging movement is not very disturbing. In any case, these experiments with an improvised tracking movement of the camera result in many duds and only a few lucky hits.

Effects with Accessories and Gadgets

There are very many effects that can be obtained by the use of lenses of different focal length, as well as special lenses and lens attachments. The zoom lens offers a variety of opportunities.

The zoom lens as effect lens

A zoom lens is a lens of variable focal length; in today's Super-Eight cine-practice it is used almost exclusively because the focal-length adjustment makes it possible always to fill the frame with the subject. This is of special significance with a film that does not lend itself to part-enlarging. This special lens makes a kind of pseudo-tracking effect possible.

In still photography, on the other hand, zoom lenses are still too expensive and bulky to play more than a subordinate role. In still photography, too, zoom lenses are used to:

1 Adapt the focal length exactly to the required image size.
2 Change the focal length quickly and simply.
3 Retain the chosen distance setting for taking a given subject through various focal lengths.
4 Facilitate the balancing of the reproduction scale and sharpness in the near-focusing range.

Disregarding normal practice, we can alter the focal length even during the exposure, a practice that seems to become more and more accepted these days. It is recommended to take such zoom effect pictures from a tripod. They resemble those shot from a vehicle moving in the direction of the object.

By the way, the new Japanese lenses whose focusing distance changes with the change of focal length are suitable for zoom effect pictures only within limits. Comparatively sharp details appear in the centre of the picture. But the blurs begin at a certain distance, varying from subject to subject, from the centre of the pictures and radiate towards the periphery with increasing intensity. The pictures give an "explosive" impression as if they were bursting, flying apart in all directions.

The difference in the extent of the blur in the centre and at the periphery is self-explanatory when we look at the behaviour of

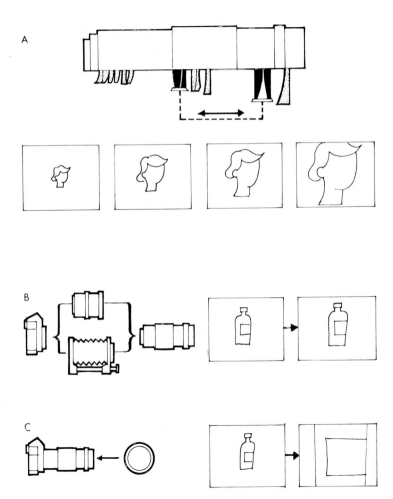

A, A zoom lens contains movable elements that change its focal length so that it can provide different sized images from the same shooting position. B, When the zoom lens is used with bellows or tubes for close-ups, the change in image magnification is slight. C, When supplementary lenses are used, the change in image size is much greater.

two image points through a magnifier. Let one be at a distance of 1 mm, the other of 6 mm from the centre of the picture. Let us take an 80 - 240 mm zoom lens in a single-lens reflex camera, and fully utilize the 3 x zoom range to obtain our effect. The part of the object occupying the 24 × 36 mm frame at 80 mm focal length will at 240 mm focal length require a picture area of 72 × 108 mm. Quite obviously this is not available; as a result part of the subject, indeed its larger part, spills beyond the picture area. Only $1/9$ of the original area is covered, although it is magnified 3 times linearly, and its area 9 times. But if an image is blown up to such an extent, each of its elements necessarily moves further away from the stationary centre – in our case its distance trebles: the point originally 1 mm from the centre moves through 2 mm to 3 mm, the point at 6 mm through 12 mm to 18 mm. That an element moving 12 mm across the film produces a far greater blur than one moving only through 2 mm is fairly obvious.

Details that move through only a very short distance – of a magnitude of about 0. 1 mm – are rendered sharp. We can, in fact, depending on the degree to which we zoom the lens in or out, either keep the sharp circle in the centre of the picture as large as we wish or eliminate it completely.

The ratio between the sharp central and the unsharp peripheral portions of the picture is determined by the extent to which the focal length of the lens is changed during the exposure. The extension of the focal length depends in turn on three factors:

1 On the angle of rotation of the focal-length-adjustment ring on the lens.

2 On the zoom of the focal length scale within which the rotation occurs. In the handy Leicaflex 45–90 mm Angenieux f 2.8 lens, rotation through a given angle produces always the same percentage change in the focal length, whether the rotating movement starts at 45, 60, or 80 mm focal-length setting. Conditions are different in other lenses. The Schneider Tele Variogon, for instance, requires roughly the same rotary adjustment from 200 to 240 mm as from 80 to 88 mm, although in the first case the focal length change is 20 per cent, in the second case only 10 per cent. At the bottom end of the scale the change therefore takes place at only half the speed.

3 On the shutter speed. If we move the scale wheel always at approximately the same speed within a given range, the ratio between the sharp and the unsharp zones can be at least to some extent controlled with the shutter speed. This would be possible at high precision if the camera had a power zoom like many Super-eight cine cameras. This would also eliminate the risk of camera movement or camera shake, which can create difficulties when the lens is zoomed by hand.

Serial experiments at various shutter speeds have shown that at $1/250$ and $1/500$ sec large sharp central zones are preserved in spite of considerable zooming.

Here is another tip concerning exposure: if bright and dark details are uniformly distributed throughout the entire subject, you can blindly trust the reading of your meter. Bright subjects in front of a dark background, on the other hand, can stand an exposure increase from 50 to 200 per cent. I am thinking mainly of the night scenes under the city lights which are particularly suitable for zooming and many other subjects to be discussed in the next section.

Zoom effect photographs in the close-up range, which will also be described in detail, deserve special interest. But you must bear in mind that if you insert extension tubes or bellows between camera body and zoom lens you will not obtain a zoom effect picture, because as you alter the focal length the focus changes. What, awkwardly enough, changes insufficiently if at all is the reproduction scale. You can transform small objects into exploding blurred stars only with the aid of supplementary front lenses.

Striking zoom effect variations

The methods just discussed by no means exhaust all the possibilities of pictorial zoom effect applications. Far from it, we are only at the beginning. All the effects I am about to describe aim at modelling the nucleus of a picture from its blurred halo.

The simplest way is to keep the exposure time as long as possible and divide it into two or more stages. The focal length of the zoom lens must alternately remain unchanged and expand or contract.

This creates an effect, in fact quite a profusion of most varied effects, depending on whether we

1 Start with the minimum focal length of the lens, increasing it at the next stage
2 Work from the opposite direction i. e. from the maximum focal length
3 Choose a rest position somewhere in the middle range of the focal length and zoom both in and out,
4 Stop the focal length variation twice, e. g. before beginning and after finishing the zoom at the shortest and longest setting of the focal length respectively
5 Zoom, if appropriate, in three, four, or even more stages.

This method will hardly be successful with moving objects. The only way to achieve your aim is to use one or several flashes, pinpointing one or several sharp pictures from a colourful mixture of blurred movement tracks and zoom effects. Flash and constant light in different colours are particularly attractive, see p 47. The fan-strobe method, too, is very useful, p 48.

With all these, as well as with special zoom effects described later, the pictorial impact depends on very largely on the nature of the background. If this is restless, the marginal zones of the picture will present a weird confusion of blurs, almost submerging the more delicate rays fanning out from the object.

In front of a uniformly bright background, on the other hand, the main subject breaks up into a mass of fringes dissolving in turn into nothing. Both length and prominence of these fringes depend on the exposure time, which must on no account be too generous.

I particularly like to take bright or even shiny objects in front of a dark background, which may be black, dark blue, dark red, or dark green. Each time the bright blurred rays will stand out luminously against it. Zoomed subjects in front of a dark background usually tolerate generous exposure, particularly when the marginal zone has markedly bright hues or is very brightly lit by bilateral glancing or by contre-jour light.

Apropos subjects with bright rims in front of a dark background, such as glassware, metalware and contre-jour portraits: they are

the most suitable ones for my special-zoom effect – a fur hat, two-stage exposure trick. In practice I proceed as follows:

I take the Leicaflex 45 – 90 mm Angenieux f 2. 8 zoom lens, and shine weak light (40 – 60 W filament lamps or coloured Comptalux reflectors) on my object to be able to give a long exposure, close the lens stop as far as possible, reduce the focal length to 45 mm, and open the shutter with a cable release fitted with a locking screw. The first stage of the exposure, during which the focal length remains unchanged, is brought to an end by my fur hat, which I place in front of the lens (other double exposure methods are neater, but not as convenient). I use the dark interval to increase the focal length slightly, say to 65 mm. Now follows exposure stage No. 2, during which I zoom the lens leisurely from 65 to its maximum of 90 mm.

The result: a sharp central picture appears surrounded by an also sharp circular halo; but the main part of the rays, strangely enough, does not cut across the contours of the central picture. The blurs begin only at a certain distance from them. Some "escaping" rays, originating in reflections in the centre of the subject, will mostly create some diversion, but this should not unduly disturb you. The main point is that the subject proper stands out markedly against the blurs. Both part-exposures are directly based on the reading of the exposure meter.

I also tried to reverse my "fur hat" method by leaving the lens at maximum focal length for the first exposure and changing it from the medium to the short focal length range during the second exposure. The result was quite acceptable – but no more than that. The following modification, however, proves superior in practice: during the dark interval between the two exposures not only the focal length, but also the focus is altered. This blurs the light tracks, or even forms a kind of halo around the object, like that sometimes seen around the moon on a chilly night.

The division of the exposure into two stages also offers us the opportunity to change the illumination during the dark interval. Take the example of a silver bowl standing in front of the camera: it is first illuminated very softly with light bounced from the walls and the ceiling and thus recorded as a main feature. For the second exposure it is lit with direct rim light. This produces really remarkable zoom blurs.

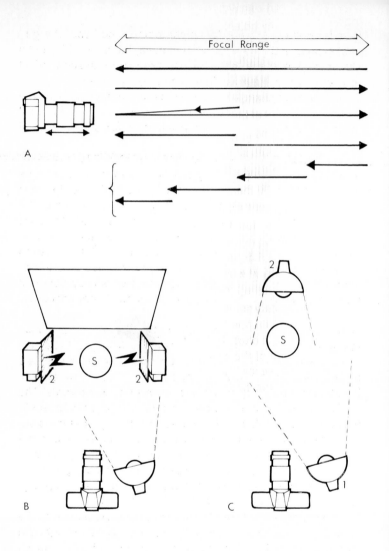

A, Zoom variations during the exposure as described in the text.
B, The subject is first photographed with frontal lighting (1) and
then with coloured sidelighting (2) while the zoom control is
operated. C, A similar arrangement with frontal lighting (1) and
contre jour lighting (2).

Here is another example: let us photograph the head of a girl. First exposure at focal length unchanged, full face, with frontal illumination (perhaps flash). Second exposure with zoom effect profile picture in artificial light in contre-jour setting.

Contre-jour subjects can of course be photographed also with multiple exposures without blur effect merely at different focal lengths at each stage. This will produce pictures with nests of contre-jour-light rims.

Nothing will differentiate between the main picture and the blur as efficiently and as effectively as a change in the colour of the light. I recently photographed a corkscrew on artificial-light film at first at a short, unchanged focal length in artificial light. But during the zoom I held an orange filter of the type normally used in black-and-white photography in front of the camera lens.

Glassware illuminated by fairly diffused daylight entering through a window, on the other hand, appears blue on artifical-light film and the differentiation can be provided by coloured Comptalux reflectors used for the second, zoom-effect, exposure.

I have so far taken it for granted that the blurred tracks radiate uniformly in all directions. But this requires the object to be projected quite precisely into the centre of the picture area. If we move it downwards, the blurred rays will all drift downwards, too, if we move it upwards all the rays will also move upwards. The corresponding phenomenon will occur if we move our object to the right or left, or diagonally. If necessary, the object sending out blurred rays in one direction only could later be returned to the centre of the picture by means of trimming the enlargement.

I almost forgot to describe an equally well-tried changing trick, which with the double exposure method is almost obligatory: changing the object itself during the dark interval.

As an example, let us take a head with our first exposure with the focal length unchanged. While the fur hat blocks the light the model is replaced by a ring cut from silver foil. This is the object which is zoomed and reproduced either in or out of focus.

Even the elementary long-time exposure with simple maximum zooming can result in very complicated compositions, i. e., when a moving object is photographed. Of the many possible combinations of movement blur and zoom blur I want to describe only

one. Remember the revolving bodies (p 61)? They can be presented in a particularly intriguing manner with the aid of the zoom lens. I use asymmetrically suspended thin objects, wires, anything that is suitable for making garlands. As soon as this object rotates evenly and slowly I zoom the zoom lens from end to end. This produces a nest of spiral figures. If you pan the camera according to the garland method (p 63) during zooming the figures obtained will be wedge-shaped and receding. Before you even realize it you are taking pictures that owe their existence to a triple movement:

1 The focal length of the zoom lens is increased
2 The object rotates
3 The camera is panned.

I have deliberately chosen as an example an object that repeats its motion rhythmically at constant intervals.

Successful pictorial results are likely only if either they still convey a suggestion of the object or a decorative figure is created by the conversion of rhythm into an ornamental structure (time is broken up by rhythm, space by ornamental composition). Here, too, we have reproductions not of the shape of the object, but at least of the natural law of object motion.

Perspective effects with wide-angle lenses

The shorter the focal length of a lens, the more pronounced the perspective distortion it produces, or more accurately it is reputed to produce. In reality all conventional lenses record their object in the same perspective irrespective of their focal length. This statement may seem to be contradicted by the fact that many wide-angle and long-focus pictures display pronounced perspective distortion that is not usually present with standard focal-length lenses.

The reason for this is that the wide-angle lens can be used much closer to the subject than the long-focal-length lens and that the long-focal-length lens naturally tends to present long-range pictures as if they were taken from much closer.

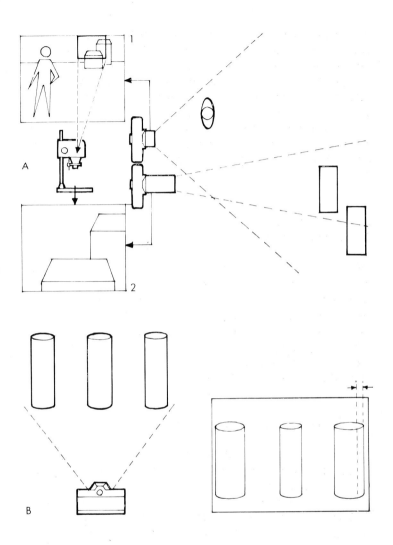

A, Provided the shooting distance is the same, perspective is unaltered whatever the focal length of the lens. The perspective in a portion of the short-focal-length lens shot (1) is the same as in the long-focal-length lens shot (2). B, The wide-angle lens causes three dimensional objects at the edges of the picture to look fatter than they are.

A long camera distance compresses objects in great depth so that they appear within a shallow depth of space. In landscapes miles away even subjects situated at a considerable distance in depth look as if they were stuck to and on top of one another, for the object at the rear is shown at almost the same reproduction scale as the object in front of it. Whether such a subject is photographed with a longer or a short-focal-length lens will affect the size of the picture area covered and the total reproduction scale, but not the dimensional relationships of the individual object details to one another. There is no basic difference (apart from the definition) between a picture with a telephoto lens and a corresponding part-enlargement of a wide-angle picture.

A short camera-to-object distance emphasizes and exaggerates the effect of space. Objects spaced in depth are reproduced at greatly differing reproduction scales, as the following table shows.

REPRODUCTION SCALES AT VARYING DISTANCES

Distance from front object	Distance between front and rear object	Difference between the reproduction scales	
		linear	area
1	1	$2 \times$	$4 \times$
1	3	$4 \times$	$16 \times$
1	7	$8 \times$	$64 \times$

But in normal circumstances, only wide-angle lenses are able to accommodate large close-up objects within the picture area. The typical exaggerated wide-angle view is therefore in the last resort due to the ability of very short-focal-length lenses to approach the object extremely closely without any sacrifice of picture area. If we do use ultra-wide-angle lenses for effect pictures, it is essential to move in on our subjects really closely. Ultra-wide-angle lenses have a focal length shorter than the narrow dimension of the film format; the upper limit for 35 mm ultra-wide-angle lenses therefore lies at 24 mm. The lower limit is about the 15 mm of the Zeiss Hologon. This fixed-focus lens, which at the fixed stop of f 8 renders everything sharp between 50 cm (20 in) and infinity, is a fixed component of a viewfinder camera, the Hologon Super-

wide. Most other lenses of such short focal length render the object in spherical perspective, and can therefore no longer be classed as ultra-wide-angle lenses; they are called "fisheye lenses" (p 82).

It has recently become possible to design 20 – 21 mm lenses of such a long back-focus that they can be used without restriction even in single-lens-reflex cameras. As an old Leica hand I use – did you expect anything else? – the 21 mm Super-Angulon-R f4 with the Leicaflex SL. It gives me an object field of 14. 8 × 22. 1 cm (6 × 9 in) at the minimum focusing distance of just under 20 cm (8 in). Since this corresponds to a reduction ratio of more than 1 : 6, this ultra-wide-angle lens takes me well into the close-up range even without accessories.

I have nevertheless bought a supplementary front lens of 4 dioptres (focal length 25 cm) which enables me to approach my object extremely closely to about 12 cm (5 in) and to obtain an object field of about 9 × 13 cm (about $3^3/4 \times 5^1/4$ in), a reduction ratio of just under 4 ×.

The marginal unsharpness that could be produced by such a powerful supplementary front lens at full camera lens aperture disappears without a trace at f8 – quite apart from the fact that it would in any case not be unduly disturbing in effect pictures.

I am now in a position to obtain a sharp photograph of a portion of a face shown very large, with a huge bulbous nose, or to contrast an enormous outstretched hand with a tiny head.

But let us leave the supplementary front lens for a moment. If necessary, elongated objects – cigars, trumpets, bottles – may almost touch the camera lens. This of course produces a slightly unsharp rendering, which does not matter so long as we focus the lens on a more distant, small, but interesting detail.

All objects of any significant depth projected into the marginal zones of the picture area by an ultra-wide-angle lens appear elongated. An object such as a ball shown as a perfect circle in the central area is transformed into an egg-shaped structure when it moves to the periphery. A head, for instance, very close to the left- or right-hand margin of a horizontal Super-Angulon photograph will appear thicker by about a quarter (elongation factor 1.3 ×). If the film material, which should be as slow as possible, permits strong part-enlargements, the distortion factor can

easily be used on purpose in a pictorially creative – or destructive – sense.

This does not apply to two-dimensional objects in a plane parallel to that of the film in the camera. A flat disc so oriented, whether at the centre or the edge of the picture area, is reproduced by the good lens as a perfect circle.

Behaviour of fisheye lenses

We have up to now taken it for granted that the camera produces pictures based only on central perspective. The so-called fisheye lenses, however, produce spherical perspective; they have the extremely wide angle of field of 180° or nearly 180°. For the 35 mm format their focal lengths are between 7 or 8 and 17 mm, for the medium format about 35 mm. The depth of field extends from infinity to close-up, often almost up to the camera lens. The picture area projected on the film is usually a circle inscribed within the 18 × 24 mm format. Some fisheyes, however, project a circle circumscribing the whole format.

As I have introduced the term "spherical perspective" I owe you some explanation and a comparison with central perspective. I will call on the assistance of Albrecht Dürer, who studied perspective in detail and reproduced central perspective projection.

BEHAVIOUR OF STRAIGHT LINES IN VARIOUS PERSPECTIVE RENDERINGS

Lines in the object space	Rendering with normal central perspective	spherical perspective	cylindrical perspective (horizontal format)	cylindrical perspective (vertical format)
Horizontals intersecting the optical axis (always dividing the picture into top and bottom half)	straight horizontal	straight horizontal	straight horizontal	straight horizontal
Vertical intersecting the optical axis (always divide the picture into right and left half)	straight verticals	straight verticals	straight verticals	straight verticals

Lines in the object space	Rendering with normal central perspective	spherical perspective	cylindrical perspective (horizontal format)	cylindrical perspective (vertical format)
Horizontals parallel to the image plane but not intersecting the optical axis (found everywhere in the picture except in the centre)	straight horizontal	in the top half of the picture curving towards the top, in the bottom half toward the bottom	in the top half of the picture curving towards the top in the bottom half toward the bottom	straight horizontal
Verticals parallel to the image plane, but not intersecting the optical axis (found everywhere in the picture except the centre)	straight vertical	in the left half of the picture curved towards the left, in the right half towards the right	straight vertical	in the left half of the picture curved towards the left, in the right half towards the right
Horizontals receding into the depth of space not intersecting the optical axis	straight oblique	oblique curved	straight curved	straight oblique
Because the camera is tilted, verticals are not parallel to the film plane, nor do they intersect the optical axis	straight oblique	oblique curved	straight oblique	oblique curved
Notes	—	object seems to evert towards the camera. Marginal details appear much farther away than central objects	verticals appear as in ordinary, horizontals as in spherical projection. Details along the left and right margins seem to be particularly far away	horizontals appear as in ordinary, verticals as in spherical projection. Details along the upper and lower margins seem to be particularly far away

On the left in his well-known drawing is the bare – in the true sense of the word – subject. Arranged in front of the subject we see an area divided by a square grid – the projection area. Because it is essential that the painter should sight the projection area always

from the same point of view, he sits directly behind a sighting device. Without grid and at a reduced scale the whole set-up is well known to the photographer in the form of the frame finder used for sports photography.

The projection area could also consist of glass – when the painter would merely have to trace the outline of what he sees with a masking crayon. In Dürer's arrangement he needs a fairly long arm to do this. After all, he must not take his eye from the sighting device while he is drawing.

Spherical perspective

So much for central perspective. To achieve spherical perspective all we have to do is replace the plate with a hemispherical fruit bowl. Its cavity must face the object, its vertex the eye. The traces of the masking crayon produce spherical perspective. Poor Albrecht Dürer – the things we ascribe to him! Since we are already comparing various types of perspective, may I anticipate the subject of the next chapter and mention the panoramic camera and with it a third, the cylindrical, type of perspective? Our plane in Dürer's picture, which has already given way to the hemisphere, is now replaced by a glass half-cylinder, which must be sighted through the sighting device.

The various types of perspective are best recognized in the photograph by the distortion of straight lines. I have tabulated the phenomenon on pages 82 and 83.

Our table reveals that in spherical projection all straight lines passing through the centre of the picture are rendered as straight as in central perspective. The fisheye photograph of an object whose main lines converge on the centre therefore differs very little from a conventional photograph. The spherical projection can be recognized only by the inversion effect, i. e. by the fact that the details shown along the margin are rendered at a smaller reproduction scale than features in the centre of the field.

Reflections in a Christmas tree decoration can be used as a fisheye substitute; they are, however, a very poor substitute indeed, because they include the photographer and the camera in the picture. But the involuntary self-portrait will be the smaller the

longer the focal length of the lens used. Focusing may present some difficulties in cameras other than single-lens-reflex models because optically the mirror image is situated a little in front of the surface of the globe.

The panoramic camera

I still owe you an explanation: I have just told you about the cylindrical perspective that is produced by the panoramic camera. What is a panoramic camera? It is a type of camera whose lens swivels during the exposure. Something completely new, then? On the contrary, it is very old indeed, having been invented more than 125 years ago.

In 1844, five years after the invention of photography, Friedrich Martens mounted a movable lens on an axis. The angle of view of this assembly was, remarkably, 155°. To enable the optical axis, swivelled with the camera lens, to remain vertical to the light-sensitive projection surface in all phases of rotation, Daguerre's silver plate, which was the exposure material at the time, had to be curved semicircularly. This created difficulties. The original European invention was patented in America in 1894. In the meantime the process had acquired additional practical value because of the advent on the market of flexible roll film. The best-known modern panoramic cameras for 35 mm film are the Japanese Panon Widelux, angle of view 140° horizontal, 55° vertical (occasionally available from photo-dealers), and the Russian Horizont.

Its 28 mm fixed-focus f2.8 lens swivels during the exposure on a cylinder jacket from left to right. During the usual horizontal exposure it covers a horizontal angle of view of 120° and a vertical angle of view of 45°. The swivelling movement takes about $1/3$ sec irrespective of the shutter speed. The shutter speed is adjusted to $1/30$, $1/125$ or $1/250$ sec by a change in the width of the slit moving across the film, which is held in a curve at the back of the camera. The viewfinder neither covers the full angle of view, nor does it sufficiently indicate the curvature of the horizontals. The lines appear the more strongly curved upwards or downwards the closer they are to the top or the bottom margin respectively of the

film format. Lines passing through the centre of the picture field are reproduced as straight lines.

The image of a spirit level is reflected into the viewfinder. It permits perfect alignment of the camera, without tilt or rotation, either on a tripod or handheld. This is important in the normal use of this panoramic camera.

Since only a few people today are familiar with the panoramic camera, I must briefly describe its normal use before we proceed to its more eccentric applications. Normal in this context means that the typical curvature of the horizontals just described is not noticed in the pictures. This can be achieved if the following five points are observed:

1 The panoramic camera is used for horizontal pictures

2 By means of the spirit level the camera is lined up straight, level, and without tilt. This places the horizon exactly in the centre of the picture, where it will be reproduced as a straight line.

3 In landscape subjects in which except for the horizon no well-defined straight horizontal lines occur the unaccustomed curvature will be completely overlooked.

4 Subjects including exterior architecture must be taken from the greatest possible distance. This places the horizontals (gables, rows of windows) near the centre of the object field. As a result the curvatures are almost completely suppressed (the fixed focus lens of the camera renders objects at infinity sharp at any diaphragm setting).

5 If possible, exterior architecture should be taken edge-on. Especially the front aspects of near buildings, which are therefore reproduced large, must not be sighted at right-angles in the viewfinder.

Now I have to admit that even architectural photographs in which lines strongly curve do not necessarily appear eccentric. When they are extremely enlarged as well as viewed from an extremely short range we regard them as perfectly normal. For if the eye is forced to scan the curving lines bit by bit with movements of the head and pupils rolling the brain will translate all the curves into straight lines. This applies particularly when the giant enlargement or the projection screen forms itself a semicircle.

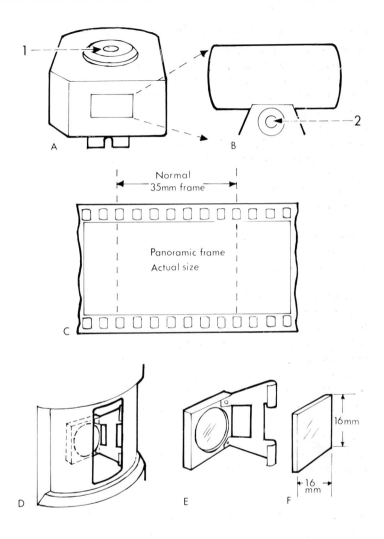

Normal
35mm frame

Panoramic frame
Actual size

16mm

16 mm

Horizont features: A, The viewfinder has a built-in spirit level (1). B, The view through the finder does not include the whole image area. It reflects the spirit level (2). C, The Horizont frame compared with the normal 35 mm frame. D, The filter attachment in position. E, Construction of the filter attachment F, Cut filter or close-up lens for attachment to the filter mount.

You might like to know that the panoramic effect can be obtained also with the aid of montages of several individual pictures. It is, however, not feasible to photograph simply five individual pictures through an ultra-wide-angle lens to obtain a full-circle panorama. It is true that with these five pictures we could cover a 360° angle with the greatest of ease. Where the difficulty arises is when we join the pictures into a long panoramic series. The edges would not join up properly. Lines that ought to pass from one picture to the next either straight or in a sweeping curve would show nasty kinks at the seams. These kinks will be the less prominent and weaker:

1 The more pictures (taken with a long-focal-length lens or central sections of short focal-length pictures) are used in the composition of the panoramic view
2 The longer focal length of the taking lens and the narrower, as a consequence, the vertical angle of view it covers.

Provided the individual pictures are taken in the horizontal view with the standard lens, 10 pictures will be sufficient for the composition of a landscape panorama. For architectural panoramas a composition consisting of 12 or more parts is preferable.
With a panoramic camera a full-circle panorama can be composed from three to four individual pictures. The joins along the edges of the cylindrical perspective pictures match with extreme precision.

Effect of supplementary lenses on Horizont camera

We have now reached the stage when we must discuss a few eccentric applications of the panoramic camera. Like the fisheye lenses, panoramic cameras produce most impressive effects of curvature at very close range, and also extremely exaggerated differences in scale between object details situated in depth. At f16 the fixed-focus lens of the "Horizont" covers a minimum camera distance of 1 m (40 in).
I was not entirely satisfied with this so I asked my optician to cut me 16 × 16 mm squares from three converging lenses of 1,4 and

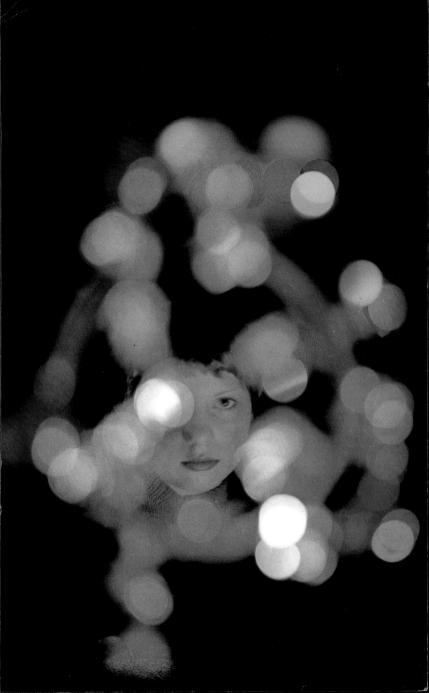

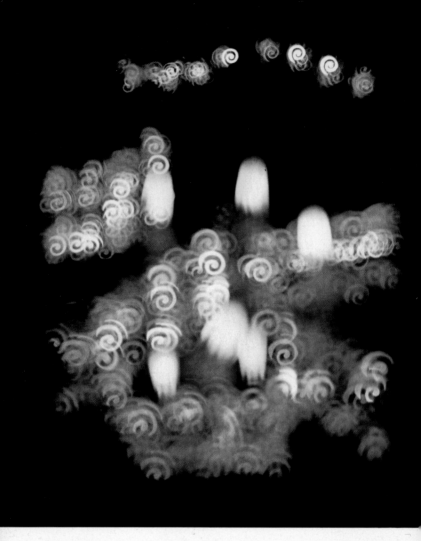

A pattern mask in front of the lens produced the spirals from flash cube reflector foils arranged on a mirror around four red candles. A blue filtered halogen lamp provided the illumination for an artificial light film.

Previous page: Reflector foils were glued to a mirror and lit by Comptalux lamps in different colours. The foils were thrown out of focus by full aperture focusing on the face.

Opposite top: Rotating wire partly covered with blue-red luminous paint and lit frontally with blue lamps. *Bottom:* Rotating, asymmetrically suspended pliers lit from behind with red and blue lamps.

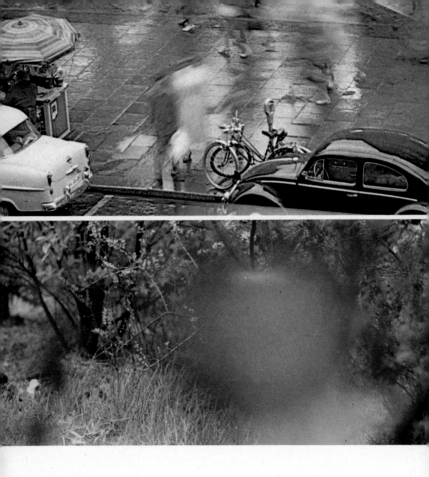

Top: Pedestrians in the rain, shot from above with a 2-sec exposure time. *Bottom:* Tulip directly in front of camera lens focused on background. *Opposite:* Face with green veil blowing across it. Shutter speed 1/15 sec.
Pages 94, 95: Effect of photographing the same subject in coloured contre-jour lighting.

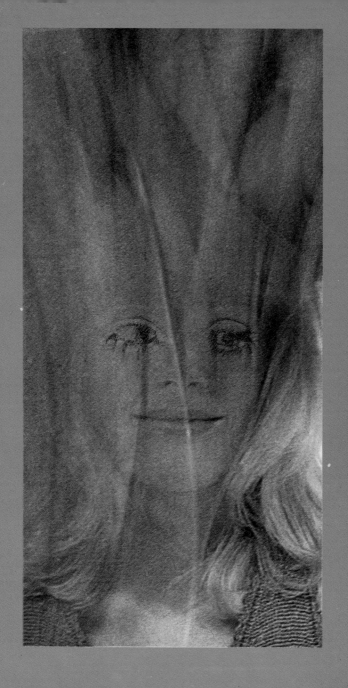

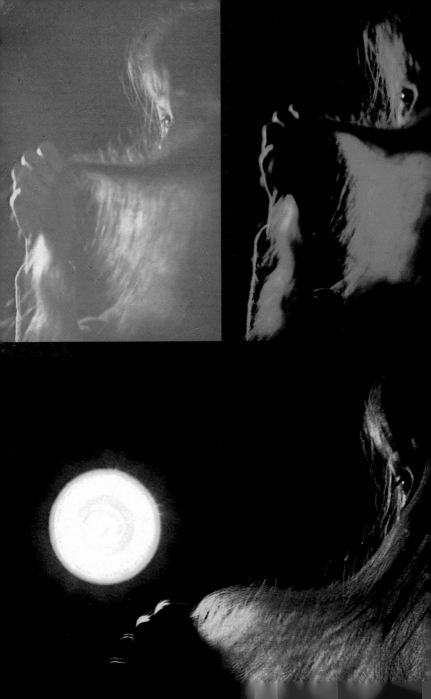

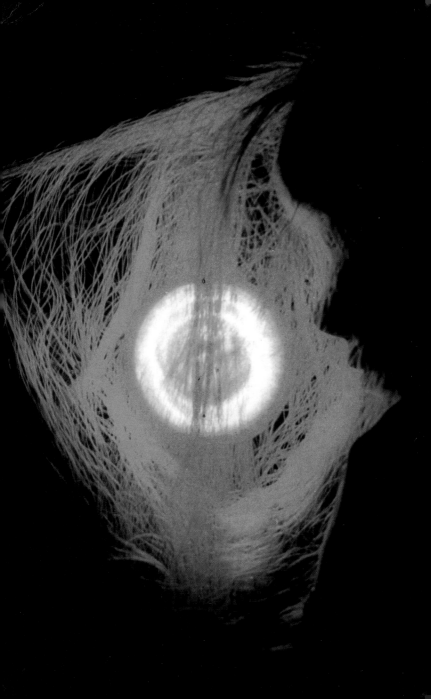

Document film negative reproduced on reversal film. An area in the background was lit with red and the silver image with oblique blue light.
Opposite: Zoom effect with green, red and orange filtered photofloods. Intermediate colours are produced where the images overlap.

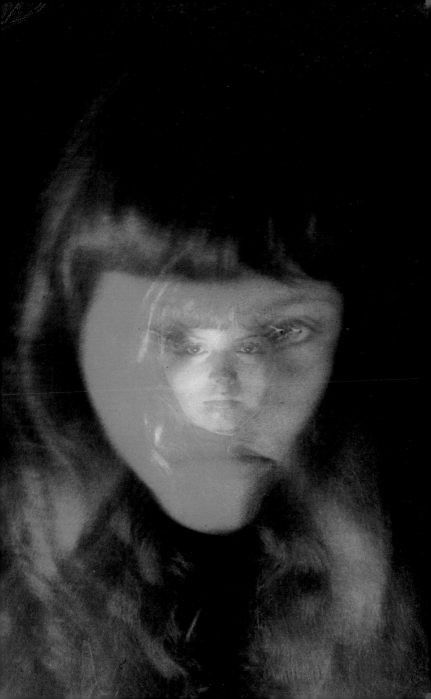

Left middle: Straightforward photograph with zoom lens in coloured lighting. *Top:* Additional exposure while zooming in daylight combined with green photoflood. *Bottom:* Fixed exposure in daylight. Second, zoom, exposure in coloured light. *Opposite:* Explosive effect produced by continuous zoom during a single exposure.

Page 100: A trick lens rotated in front of the camera during a ½-sec exposure provided this rendering of Christmas illuminations.

Page 101 top left: Suspended corkscrew rotating around its own axis, lit with artificial light and several coloured flashes. *Bottom left:* Corkscrew in a pendulum swing with coloured flashes. *Top right:* Zoom effect double exposure with focus and lighting altered. *Bottom left:* Focusing unchanged.

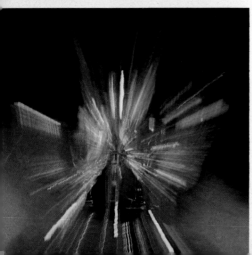

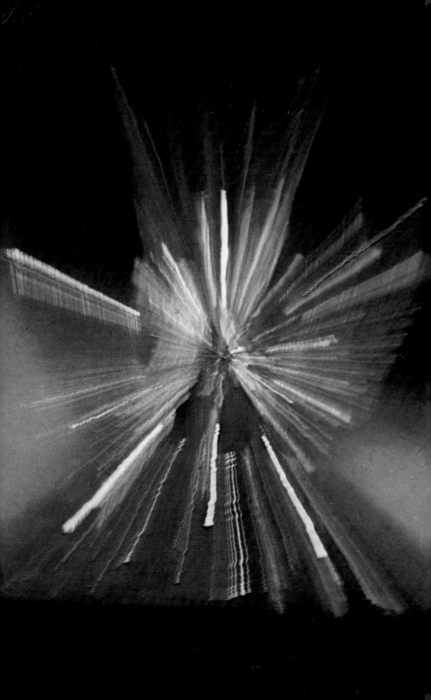

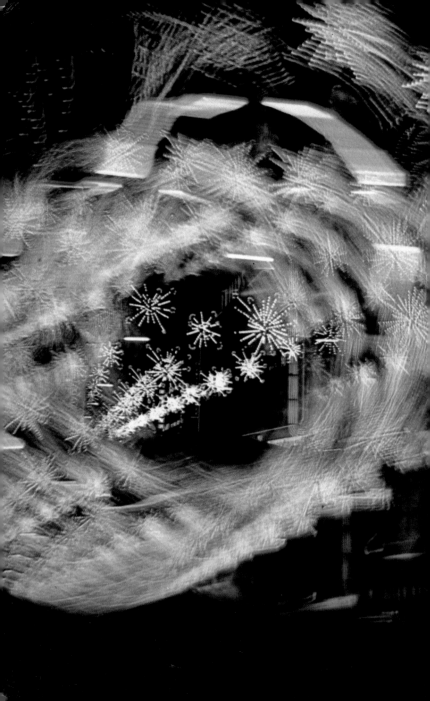

Page 102: Model railway taken through a trick lens on artificial light film with mixed daylight and artificial lighting.
Left: Small tool, immersed in champagne, lit in green and blue. *Above:* The same object lit in red and yellow and reproduced by the kaleidoscope method.
Page 104: Examples of kaleidoscope pictures produced from images on transparencies.

DEPTH-OF-FIELD TABLE FOR THE
HORIZONT PANORAMIC CAMERA

Lens stop	Depth of field at $1/20$ mm circle of confusion
2.8	5.5 m (18 ft 4 in) to ∞
4	3.9 m (13 ft 10 in) to ∞
5.6	2.9 m (9 ft 6 in) to ∞
8	2.0 m (6 ft 8 in) to ∞
11	1.5 m (60 in) to ∞
16	1.0 m (40 in) to ∞

10 dioptres. I fixed them with adhesive tape on the UV-absorbing filter supplied with the camera and thus mounted them in front of the lens.

At first 10 dioptres appear to be a little generous for a supplementary front lens. In the interest of image quality mostly lenses of $1/2$ to 5 dioptres are used for the adjustment of camera lenses to the close-up and the macro range. But here we use only the small central portion of a large lens. The marginal zones, which are usually responsible for strong optical distortions, are eliminated. All my tests have indeed demonstrated a quite satisfactory image quality.

EFFECT OF SUPPLEMENTARY LENSES ON THE
HORIZONT CAMERA

Dioptres +	Subject distance	Reduction x	Image field covered cm (in)			
1	100 (40)	32	77 \times 186	(31	\times 74)
4	25 (10)	8.7	21 \times 50	(8.4	\times 20)
5 (1 + 4)	20 (8)	6.9	16.5 \times 40	(6.5	\times 16)
10	9.4 (3.8)	3.6	8.5 \times 21	(3.4	\times 8.4)	
11 (1 + 10)	8.1 (3.25)	3.1	7.5 \times 18	(3	\times 7.2)	
14 (4 + 10)	6.7 (2.7)	2.5	6.0 \times 14.5	(2.4	\times 5.8)	

Only the close-up lenses enable us to reproduce portraits, flowers, models, structures made of building-bricks, and vessels in cylindrical perspective. I am also fond of loading my panoramic camera with document copying film (p 122) and photographically distorting old engravings, plans, and manuscripts. Naturally, photographs, too, can be reproduced with the Horizont.

A particularly interesting experiment consists in re-photograph-

ing in cylindrical perspective photographs that had already been taken in this type of perspective not once, but twice, three times, etc. etc. ad infinitum. Conversely, the panoramic camera can flatten any hollow cylindrical shape photographically into a plane. Leaving the subject of close-up photography for a moment we can obtain slightly to completely mad effects also when the camera, which is designed for horizontal pictures, is used for upright and even oblique shots. Rewarding objects are columns, spires, factory chimneys, telegraph poles. If you want to take railway tracks or motorways receding into the far distance in an upright format, keep your viewpoint as low as possible to emphasize the cylindrical curvature of the straight lines most effectively. That the photographer of nudes can conjure up with his panoramic camera and supplementary front lenses curves where the camera reproducing at conventional perspective finds only flatness has obvious attractions.

The most way-out, however, of all the panoramic eccentricities is the result of an energetic turn of the Horizont during the exposure at the highest possible shutter speed. Reality undergoes violent deformation, and gentle sweeps of lines become wild curves. With slower shutter speeds the already well-known circular blurs will also be produced.

Wide-screen distortions with the " wide-screen lens"

Messrs Isco, Göttingen, produce a complete wide-screen (anamorphic) system. The Iscorama outfit consists of three parts:
Part A, the wide-screen attachment (set of cylindrical lenses), is mounted on the basic lens (part B) for the exposure, and in front of the projector lens (part C) for projection.
Part B, the basic lens, must be inserted in the camera and used together with Part A.
Part C, the projector lens, is also used with Part A. Without the wide-screen attachment conventional slides can be shown with it. Basic lenses are available for most types of single-lens reflex camera with interchangeable lenses. Likewise, projector lenses (Part C) are supplied for a large number of still projectors. This shows that the Iscorama outfit has been developed as a combined special taking and projection system. Usually the wide-

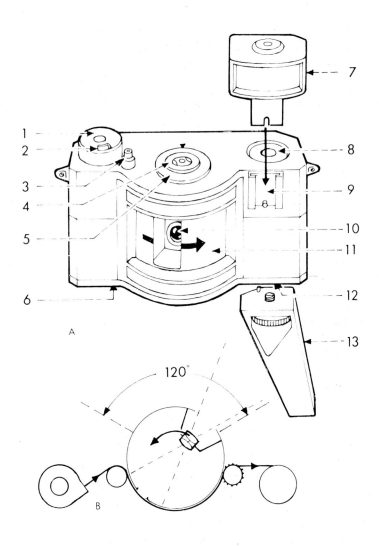

The Horizont camera: A1, Film transport knob. 2, exposure counter. 3, shutter release. 4, aperture dial. 5, shutter speed dial. 6, rewind button. 7, viewfinder. 8, rewind knob. 9, viewfinder. 10, lens. 11, rotating drum. 12, tripod screw. 13, grip to keep fingers out of picture. B, The rotating drum carries the lens in a 120° arc, while an opening at the back exposes the film sequentially.

screen attachment is set at the normal position for conventional photographs and conventional reproduction. Here the result is as if the transparencies had been taken through a 50 mm lens vertically, and a 35 mm lens horizontally, which makes the projected images 50 per cent wider than usual. But since this wide-screen image has to be accommodated within the 35 mm format, the subject detail must be squashed. Seen with the naked eye or shown in an ordinary projector, all details in an Iscorama picture appear narrower and therefore taller than they really are. A belfry, for instance, 40 m (130ft) high and 9 m (30ft) wide will be shown at its true height, but as if it were only 6 m (20 ft) wide. In Iscorama projection all the squashed details are "pulled apart" again, and the height: width ratio of the image is 2.25 : 1, compared with the 1.5 : 1 ratio of the conventional 35 mm format. The objective of the Iscorama method is to produce wide projection images, which, quite similarly to wide-screen films, create a pronounced illusion of space and three-dimensionality. This is particularly successful at favourable viewing distances – never more than twice the width of the image.

This spatial effect is naturally created also when a conventional slide is hugely enlarged by projection. This calls for the use of a powerful daylight projector, because the height of the image during close-up viewing goes far beyond our horizontal-oblong image field. Light from the projector is thus wasted on parts of the image at which we do not look; what is superfluous at the top and bottom is lacking on the left and right.

Here is an example: let us assume that it is possible to project a conventional picture at a width of 2 m (6ft 8in) at sufficient brightness. We would therefore place viewers in a space between 1 m and 2 m (3ft 4in and 6ft 8in) in front of the projection screen. At the same brightness level the Iscorama image would make a projection width of 2.7 m (9ft) possible. The space within which the viewers would clearly observe the wide-screen effect would be enlarged 1.7 times (1–2.7 m, 3ft 4in–9ft) (This example allows for a certain loss of light caused by Part A during projection).

Strangely enough, wide-screen representations are much older than photography itself. Albrecht Dürer, for instance, composed many of his landscapes in an exaggeratedly wide format. In this context I would mention particularly his water colour view of

Nuremberg from the West painted in 1496. Measuring 16.3 × 34.4 cm (6.5 × 13.7in), it has a side ratio that is surprisingly similar to that of the Iscorama format. If we assume the not at all unusual viewing distance of 25 cm (10in), a considerable illusion of spatial impression would be created. This is forcefully enhanced by the shadows, which indicate side lighting. The fact that as in many of Dürer's landscapes the horizon is near the line bisecting the picture fairly accurately into an upper and a lower half suggests that the artist did not create the picture as judged by the eye, but that he used aids to construct the perspective (p 82).

When the subject is squashed to this extent I find it somewhat difficult to focus the reflex finder image. I prefer to turn the camera into the position for the upright format, when the subject appears at an exaggerated width. I have the impression that this provides a much better sharpness control. Unfortunately I can offer no explanation for this phenomenon. If we photograph a subject at as great a lateral expansion as this – either with the camera in the upright position or with the attachment A rotated through 90° – we are using the Iscorama lens already in a rather way-out fashion. This is even more pronounced if we rotate the attachment through only 45°, when our subject becomes obliquely distorted. Occasionally this results in most bizarre and comical pictures.

My favourite subjects for the Iscorama lens are scripts, graphical representations, existing photographs (pictures taken with fisheye or panoramic cameras) as well as subjects in front of a quiet light or dark background or of the sky, because here only the main picture element is distorted; in reality the distortion of course affects the background equally – except that here the effect is invisible.

During the final proofreading of the manuscript yet another possibility of composition occurred to me – but too late to be practically tried before the book went to press. The background behind a small subject can of course also be a back-projection image, normally produced on a translucent-paper screen with a projector lamp or with flash.

It should therefore be an attractive proposition to use a distorted Iscorama projection image which is reneutralized by the reverse setting of the Iscorama anamorphic taking lens (i. e. two A attachments are required). The background, distorted in projection, will

then appear undistorted. The undistorted object in the foreground, on the other hand, will be rendered completely deformed in the picture.

Projection, then, is a means of modification: ordinary transparencies can be stretched, squashed and obliquely distorted. Subjects in Iscorama transparencies appear normal, warped, or extremely squashed depending on the rotation of the cylindrical lens attachment (by the factor 1 : 2.25 when camera and projection distortion add up). The picture will look quite funny if we rotate the attachment slowly from normal to "way-out" during projection; the oblong picture is transformed into a square one.

A black-and-white or colour negative picture can of course be stretched practically without limit by multiple reproduction. Stretching or squashing the subject through reproduction calls for a front lens attachment. The focusing range of the Iscorama lens extends only between 2 m (6ft 8in) and infinity. For close-ups as well as reproductions I always use a +4-dioptre lens. The object field recorded measures about 27 × 12 cm (11 × 5in).

Combined with the Iscorama attachment extension rings and bellows units do not produce sharp pictures. Since the image distance cannot be enlarged at will, it is also difficult to adapt the special lens set to enlargers. This is possible only if the distance between lens and negative can be kept as short as for the camera exposure. Collecting lenses·are essential to focus the projected image sharply on the baseboard.

I also tried to use two cylindrical attachments (A + A + B) for the exposure. This is basically possible. It directly produced a distortion of 1 : 2.25. Unfortunately it is a little difficult to mount the second attachment on the first. In addition this causes strong vignetting. Only a very small portion of the entire image field can be utilized.

To clarify the at first glance complicated relation between Iscorama picture and projection or reproduction, I have tabulated the effects in detail.

Let me conclude with the most way-out tricks of all: rotate the cylindrical lens attachment during a long-time exposure. If you have only a few luminous points in the viewfinder – night pictures of illuminations, reflections in glassware – you will obtain interesting designs of curved lines. Otherwise the results will re-

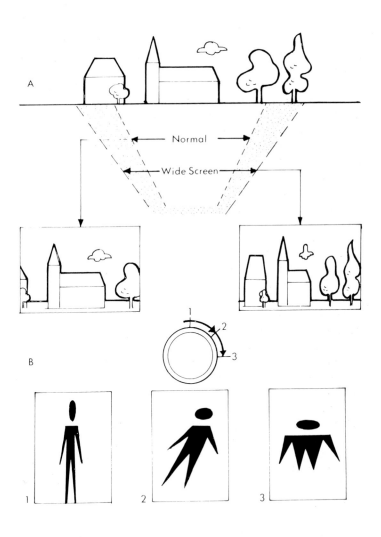

A, The anamorphic or wide-screen lens compresses a wider-angle view into the normal 35 mm frame. B, When the anamorphic lens is normally positioned (1) the subject is compressed in width. With a 45° turn of the lens, the subject is obliquely distorted. With a 90° turn, the subject is foreshortened and therefore appears fatter.

DISTORTION PROVIDED BY WIDE-SCREEN DEVICE

Picture	Normal		Iscorama		Iscorama rotated through 90°	
	Side ratio	distortion	side ratio	distortion	side ratio	distortion
normal horizontal format	normal 1.5:1	none	ultrawide 2.25:1	wide 1.5 ×	square 1:1	high 1.5 ×
normal upright format	normal 1:1.5	none	square 1:1	wide 1.5 ×	ultrahigh 1:2.25	high 1.5 ×
Iscorama normal horizontal format	normal 1.5:1	high 1.5 ×	ultrawide 2.25:1	none	square 1:1	high 2.25 ×
Iscorama normal upright format	normal 1:1.5	high 1.5 ×	square 1:1	none	ultrahigh 1:2.25	high 2.25 ×
Iscorama 90 rotated horizontal format	normal 1.5:1	wide 1.5 ×	ultrawide 2.25:1	wide 2.25 ×	square 1:1	none
Iscorama 90 rotated upright format	normal 1:1.5	wide 1.5 ×	square 1:1	wide 2.25 ×	ultrahigh 1:2.25	none

semble multiple exposures of superimposed subjects with blurs.
Naturally, the pictorial impression can be controlled at will with:

1 Rapid or slow rotation of the attachment or of the camera.
2 Jerky or smooth rotation.
3 One or more stops during rotation.
4 One or several flashes, if desired with colour-filtered flash lamps.
5 Interchange of colour filters in front of the lens.
6 Combination of rotary movement with a separate movement of the lens or with deliberate camera movement.
Most peculiar effects will be created when revolving bodies (p 61) or pendulum pictures are "modified" with the rotating anamorphic attachment.

Strange effects with unusual lenses

Keen watchers of television cannot have failed to notice a recent rash of multiplication tricks on their screens. A subject is multiplied into many – 3 to 6 – individual pictures, which are occasion-

ally superimposed. Marginal pictures sometimes describe circular movements around the centre of the screen.

These complicated effects can be carried out with prismatically-ground lenses. One manufacturer recommends his lenses for both cine and still photography. Another, however, points out that such lenses are really suitable only for filming. In still photography the one-sided bevelling of the lens tends to produce colour fringes which in turn adversely affect picture definition. This is far less disturbing in filming, especially when the trick lenses are rotated.

On the basis of my own experience with still photography, however, I think conditions are much more favourable than the manufacturer's very conscientious assessment of the situation would suggest. But I do admit that a single-lens reflex camera is quite an advantage when these unorthodox lenses are used, because otherwise the effect they produce cannot be accurately judged in advance.

You must never rely on what you see when you look through one of these lenses simply as if it were a monocle. The reaction of the camera, which has the cussedness of the inanimate object, to the prismatically-ground attachment, is bound to be completely different from that of our eye. Whether in the last resort a slight unsharpness of the marginal features of the picture is found disturbing or not depends on the size of the picture area in the centre. The larger the area of the central picture, the less will unsharp elements along the margin be noticed. The effect will, on the other hand, not be very interesting if the central area is kept too large at the expense of the marginal picture zone.

Fortunately, the size of the central area can be controlled. It depends on:

1 The type of attachment lens At least four different types are available.

2 The position of rotation. The lenses are mounted in rotatable mounts like polarizing filters. Changes in the rotation position result in radical changes in the pictorial impression.

3 The camera lens stop. The larger the lens stop, the smaller the central zone and the larger the marginal pictorial elements penetrating the centre. If maximum aperture is used there will often

not be an area left in the photograph which is not occupied by two or more superimposed picture elements. Radical stopping down eliminates these intersections from the central zone and expands the zone enormously. It pushes the marginal features into the corners, and occasionally even off the picture area altogether, especially where long-focal-length lenses are used.

The longer the focal length of the lens used, the larger the central picture area. (Don't misunderstand me: this does not refer to the reproduction scale, but only to the dimensions of the central area). Standard focal lengths for 35 mm cameras (45–65 mm) are most suitable for the trick lens effect.

The diagram on p 115 illustrates seven types of trick lens. Some of them have smaller central areas. From what we have discussed here this has two results, which in my experience are amply demonstrated in practice:

1 For photographic purposes the lenses with the smaller central areas should be used with standard lenses at medium to small stops. The somewhat less favourable longer focal lengths require medium stops. But quite attractive effects are obtained with considerably stopped-down long-focal-length lenses if the trick lens instead of being mounted directly on the camera lens is held a few centimetres in front of it.

2 The other trick lenses should be used with standard camera lenses at large apertures. The slightly less favourable short-focal-length lenses must be stopped down.

The most suitable subjects for multiplication effects are bright objects of simple shape in front of a dark background. Bright backgrounds raise very difficult problems indeed, because they excessively reduce contrast and colour brilliance if the multiplied elements are superimposed.

Trick lenses demand much contrast in the subject. If necessary, the fantastic character of trick lens effects can be further enhanced by the following measures:

1 Two trick lenses are screwed together and mounted in front of the camera lens. But we shall achieve satisfactory results usually

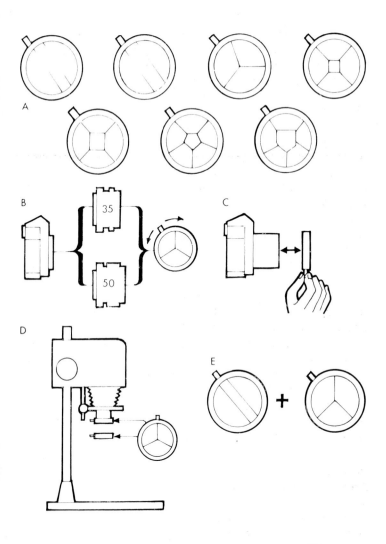

A, Types of trick lens for multiple image photography. B, The effect can be varied by changing the focal length of the lens and by rotating the attachment. C, The attachment can be moved toward and away from the lens to vary the blur in the radial zones. D, The attachments can be used on the enlarger. E, Trick lenses can be mounted together on the camera lens.

only when we combine three-sector lenses. Furthermore, we must expect the colour fringes of the marginal picture elements to become more pronounced.

2 The trick lens is turned in front of the camera lens during the exposure, whereby, depending on the degree of stopping down, a more or less extensive central area can be rendered sharp. The marginal zone, on the other hand, will show more or less prominent circular blurs according to the speed at which the trick lens was rotated. The transition between marginal and central zones appears much more marked than with the rotating-camera method (p 64). A most interesting, readily-controlled effect.

3 The trick lens in front of the camera lens is moved a little towards and away from the object. This preserves sharpness in the central zone, whereas the marginal zone will show slight radial blurs. This effect will be obtained only if comparatively close-up objects (less than 1.5 m or 60in) are focused.

4 The trick lens is held 5–25 cm (2–10in) in front of a standard-to-short-focal-length lens, when a multiple central element surrounded by a single environment will result. The lens mount will usually appear dissolved in cloudy unsharpness. I used this trick once to place the head of a rag doll in sextuplicate on a body.

I have used trick lenses on the projector and enlarged with only limited success. But suitable photographs can be multiplied with this method. To avoid a multiple reproduction of the margins of the photograph it is advisable to copy only a small portion of the original when trick lenses are used.

Kaleidoscopics

Weaned from its original purpose, even a kaleidoscope can be used for the multiplication of objects, but the result hardly justifies the effort. The double glass or plastic bottom of the kaleidoscope with the attractive coloured filter and the glass on the viewing window must first be removed. What is left is mounted in a lens hood, so that the former viewing window is situated directly in front of the camera lens. All light leaks between the outside wall of the lens hood must be stopped. Now we are ready to

Kaleidoscope pictures. A, The toy kaleidoscope usually calls for at least a doubling of the normally-indicated exposure. B, Dimensions of mirror suitable for home-made kaleidoscope. C, Three mirrors bound together with adhesive tape. D, The kaleidoscope set up for reflected light. E, The kaleidoscope set up for transmitted light.

start. How does the result differ from a picture with a trick lens? After all, the subject is, as it were, structurally modified in both cases.

The trick lenses multiply a picture right-way-round and upright. The usually three-mirror kaleidoscope attachment produces an attractive alternation of right-way-round and wrong-way-round, upright and upside-down representations.

Awkwardly enough, though, in the last resort this kaleidoscope component is not at all straightforward to use. The following problems arise:

1 As a rule, the film format is not completely utilized. Mostly only a rather small portion can be used.

2 The exposure must be increased (in my experiments by about two stops) because the viewing window of the kaleidoscope obscures part of the camera lens. In such cases selective through-the-lens metering is of course always useful.

3 The camera lens must be used at full aperture; stopping down further reduces the useful picture area.

4 The quality of the reflecting surfaces of a kaleidoscope leaves much to be desired; they consist of rear-silvered or completely unsilvered glass plates (glass surfaces act almost like mirrors on glancing light, see p 158). This produces reflected images both on the front and on the rear surfaces, resulting in double contours and consequent unsharpness.

To overcome all these drawbacks I had three surface-silvered mirrors measuring 6 × 30 (2.4 × 12in) specially made. Like all things custom-built, they were quite expensive. They also have to be treated with the greatest care because their surfaces are extremely sensitive. Fortunately they can be used also for other mirror experiments (p 158). To return to our purposes of object multiplication, first the three mirrors are arranged so that they face each other. They are provisionally held together with rubber bands. The edges are joined with black adhesive tape. The result is a mirror-prism; it is arranged with its aperture directly in front of a lens. It is essential that the triangle of the prism includes the lens without cutting part of its surface off (the minimum width of the mirrors should therefore be just less than twice the front lens diameter). This arrangement produces perfect multiplication ef-

fect photographs at any diaphragm setting. The shorter the focal length of the lens used in the camera, the smaller but also the more numerous the images of the subject reproduced in the picture. The unreflected, triangular "original field" fortunately is relatively small, because the mirror strips are very long and rectangular, unlike the mirrors of the kaleidoscope, which are trapezoidal.

Two points create difficulties:

1 The mirror image fields are darker and bluer the further away they are from the original field. There is no practical remedy for this.

2 Unfortunately, the individual mirror fields do not contain a true image of the original field, but slightly different portions of the subject. An exception: if, exactly like the kaleidoscope filters, the object is situated in front of the open end of the glass prism, it will be multiplied by the mirrors in its entire and perfect beauty.

The most beautiful effects are produced by small, translucent objects – leaves, flowers, glassware; they are placed on a light box and the prism is inverted over them. The camera points into the triangular tube from the other side. The 21 mm Super Angulon is my favourite lens for this type of work; it conjures a whole mass of ornamentally arranged mirror images onto the film. To use larger and more distant objects for perfect kaleidoscope patterns, we could in theory first obtain an image on the groundglass screen of a large-format camera and could then photograph the groundglass-screen image as just described through the mirror prism. But I prefer to arrange black-and-white or colour transparencies on a light box for transillumination, place the mirror prism on top and reproduce them through it. The originals must, however, measure at least 6 × 6 cm.

Special
Black and White
Effects

Colour photography may not be able to displace its black-and-white rival completely, but because of its wide-ranging creative possibilities, has very nearly done so. This applies particularly to abstract photography, which revels in playing with fantastic colours. Yet, I should not like to ignore trick photography in black and white completely, especially since its results are urgently required as intermediate products for more or less eccentric colour compositions.

Graphic work with document-copying film

In printed matter, you will often come across photography-based graphic illustrations; most of them are taken on document copying film. Normally this is used to photograph drawings or manuscripts so that all that remains is black figures on a white background. I like to fall back on this material to reproduce photographs and thus to convert them into graphic compositions. In the process I sometimes distort them cylindrically, spherically, or anamorphically.

The various manufacturers produce various types of document-copying film. It must usually be specially ordered from the photo dealer. You must use your own judgment regarding exposure data. The manufacturer's recommendations apply when the subject consists mainly of very dark and very bright tones. With delicately graded grey tones the problem of exposure is largely a matter of assessment, depending on which tones we want to appear black, and which white (very delicate grey tones will be converted into pure black-and-white features only if an extra-hard enlargement of a negative taken on document-copying film is once again copied on document-copying film).

Let us leave the topic of reproduction for a moment. You can photograph any subject you like, not just subjects for photographic eccentricities, on document-copying film.

The real graphic effects will appear on document-copying film in very soft lighting, in dull weather under an overcast sky, or in bounced artificial light or flash. This particularly accentuates the details in light or dark tones. Neither shadows nor highlights can interfere with them.

Examples: in portraits, freckles will stand out as black dots against a light complexion. Even skin pores will be prominently shown. It may not look attractive, but it is at least original. The grain of a wooden board, as well as snow-covered pine wood will produce contrasty patterns. Zebras are absolutely classical subjects for this method. Harsh light/shadow contrasts would merely impair the impression of their graphic striped pattern.

The heavy shadows caused by glancing light may sometimes interfere with the clear shape of certain subjects, indeed completely disfigure them so that they are no longer recognizable. On the other hand, the structure of other subjects will be really brought out only with this method. When used in connection with document-copying film the same type of illumination will therefore either mask a feature or emphasize it. Glancing light is always favourable for areas with relatively slight irregularities: tracks in the sand or in the snow, wave patterns in the shallows, cracks in a wall.

Document-copying material reacts also very favourably to contre jour light. If used with skill, this type of light produces a bright light rim, which appears completely white in the hard enlargement.

Light bubbles (p 38) taken on contrasty film will be particularly brilliant. But if we want to set off sharply-rendered light points against blurred, dark outlines of objects in the foreground, our only possibility will be to use document-copying material or hard infra-red material.

Here is the place to mention indirect contre-jour light. It is the effect of an unlit object in front of a brightly-lit background. The subject therefore must be arranged in front of an illuminated wall, a transilluminated panel, or in deep shade with the blue or white sky as background. This results in an interesting silhouette effect.

Now a photograph on document-copying film need not always be an end in itself. It can be an intermediate product to be further processed, for instance to obtain:

1 A sandwich slide. Contre-jour or silhouette negatives or black-and-white transparencies made from them are bound together with colour transparencies (p 150).
2 A montage (p 151)

3 A colour transparency modification by means of optical colouring. This method particularly requires hard negatives.

Cut montage

If you want to combine various details of different photographs without revealing that the final product is a montage, the cut montage is not a particularly useful method. For "forgeries", for instance, other forms of photo-montage are vastly preferable.

There is no reason why cut montages should not be recognized as such. Take the example of the panoramic picture made up of 10 or more individual sections (p 88). These sections are precision-cut with a pen-knife and steel ruler and then laid out on a sheet of dark or white cardboard. It is really not necessary to "butt-join" the various photographs. You may leave a thin, or even a not-so-thin dark or white gap between them. I would say that far from being disturbing this will in some conditions look very attractive.

Even with cut montages of patterns it must from time to time be decided whether it is preferable to butt-join the various pictures or to leave dividing gaps between them. Patterns vary a great deal; we distinguish here between five different methods of arranging patterns:

1 Several identical pictures are joined to form a frieze. The photographs can be trimmed square, oblong, triangular or hexagonal (honeycomb shape).
2 Several of these picture sequences mounted in rows produce a patterned area.
3 Right-way-round and wrong-way-round enlargements alternate.
4 Right-way-up and upside-down enlargements alternate.
5 The most advanced arrangement: alternating right-way-round and wrong-way-round pictures in the horizontal, and right-way-up and upside-down pictures in the vertical direction. Even in the slightly more complicated triangular (kaleidoscope, p 116) and hexagonal structures we arrange the individual pictures side-by-side to create the illusion that they reflect each other.

The possibilities of cut montage are by no means exhausted by the panoramic combinations and pattern arrangements. We can, for instance, cut photographic compositions into strips or squares and mount them together again but slightly displaced. Photo-collages also come to mind here. Various details are cut from different photographs and combined to form wild, fantastic products of the imagination. Here are a few practical hints:

The harder their contrast, the better suited the photographs are for cut montages. At the same time the already mentioned gaps separating the various photographs go particularly well with graphic compositions. If for some reason or other the joins are to disappear completely, the cut edges must be dyed with black re-touching dye wherever dark portions of the pictures are to be joined. In the negative it is usually necessary to treat bright lines between dark areas with black dye. These lines are the joins be-tween areas that are bright in the original. Grey areas in pictures which ought to appear radiantly white can be eliminated with Farmer's Reducer.

Distortions via reproduction

You will find an intriguing trick described in old books on photo-graphy: heat the emulsion of thoroughly washed negatives until it becomes soft and begins to flow, and with it, of course, the sub-ject pictured in it. Following this suggestion I grilled a fair number of negatives under a 1000 W halogen lamp. Occasionally I suc-ceeded in frying the emulsion completely; but try as I would, I could not make it flow. Obviously our films today are hardened so much that distortion through heating is no longer the straight-forward matter it used to be. To achieve my aim I had to try a com-pletely new method.

I mount reasonably sized enlargements with a matt surface (or glossy paper air-dried on a rough Formica sheet) on a wooden board with drawing pins so that their surface is wavy. The whole set-up is indirectly lit and then reproduced with an ultra-wide-an-gle lens (p 78), a panoramic camera (p 85), or an anamorphic lens (p 106). If required, the end product can be treated in the same way once again, or as often as necessary to obtain the desired effect.

Special
Colour
Effects

The use of colour film naturally adds enormously to the range of effects that can be produced. Colour can be falsified by the use of filters, "wrong" light sources or variations in exposure. Different effects can be produced in the same picture.

Artifical-light colour film in daylight

I hope to prove to you that the use in daylight of colour reversal film designed for artificial light (photoflood) is by no means as eccentric as it may sound.

Let me begin with a remark on exposure technique. Most exposure meters are hypersensitive to warm light and therefore to artificial light. If they "see too much red", their deflection will be excessive (p 2). This red sensitivity of the measuring instruments is naturally allowed for in the speed rating of artificial-light films, which accordingly are rated 1–3 DIN (1.25–2 × ASA factor) faster than comparable daylight films. This of course leads to slight underexposure when such an artificial-light film is exposed to daylight. It is advisable to increase lens aperture or exposure time depending on the exposure meter/film combination used. But what is the point of exposing artificial-light film to sunlight? Don't we all know that this makes everything appear blue? Does it really? Everything? Completely? That's what you think – and what I thought; until I stopped thinking and carried out a few experiments. Here are the results:

1 Strong reds will come through also on artificial-light film. Once red, always red.

2 Strong golden yellow – and gold – may in favourable conditions be rendered as white. Orange appears bright yellow.

3 Light brown turns into violet (complexion).

4 Grey, white and green become blue (deep and yellow-green may become blue-green).

5 Black remains black – as it should.

If your subject is dominated by colours that all drift towards blue on artificial-light film, a transparency of it will obviously appear to have a blue cast. But if it includes also fairly pure white, pure

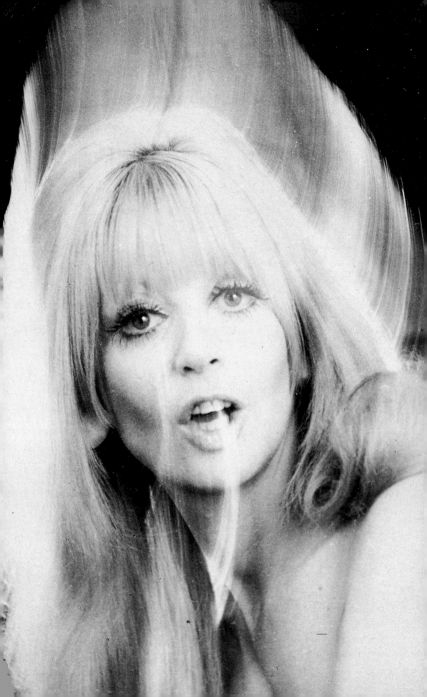

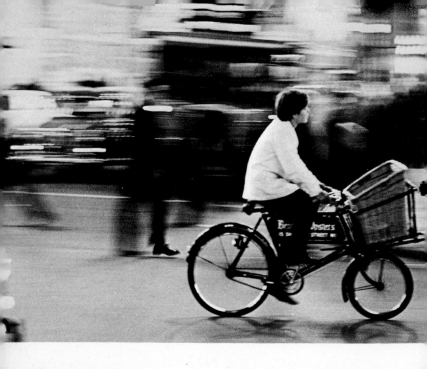

Panning the camera is a technique used to obtain a sharp picture of a rapidly moving subject. In this case, the complementary blurring of the background is the main feature and the panning was therefore carried out at a relatively slow shutter speed—*Michael O'Cleary.*

Page 129: Subject movement is a popular trick technique. In this case the model moved her head rapidly toward the camera during the exposure. A lot of light and a reasonably small aperture are advisable—*John Thornton.*

Opposite: Shooting from a bouncing car can be a frustrating business, but if you set your shutter speed to 1/30 sec, the combined bounce and forward movement produce rather interesting results—*Rudolf Bieri.*

Pages 132, 133: Combinations of identical images or parts of images to produce patterns that do not exist. The top picture uses three prints of the same subject (one laterally reversed) mounted side by side. The bottom picture turns a few trees into a wood by using five prints of the same subject—*Adolf Vrhel.*

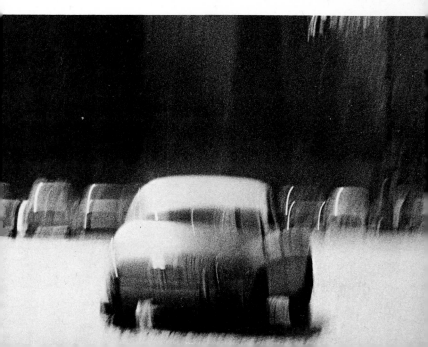

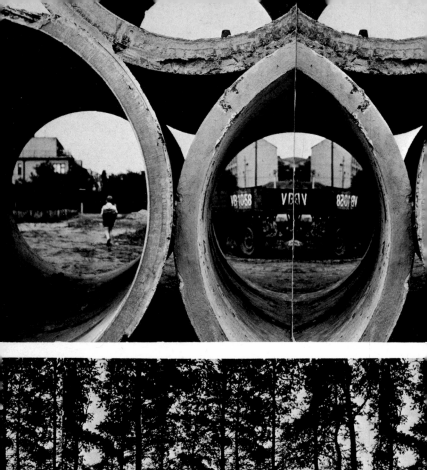

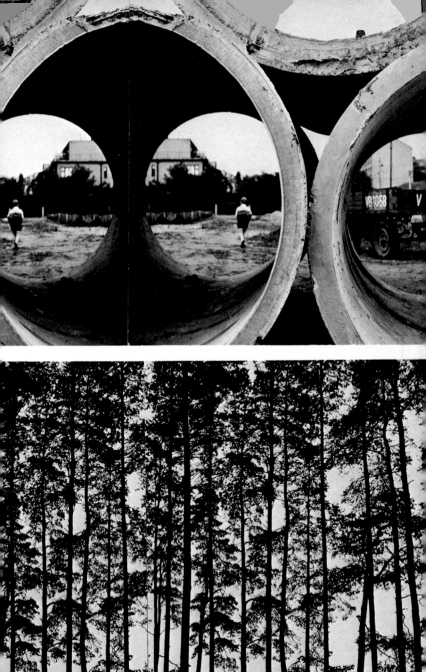

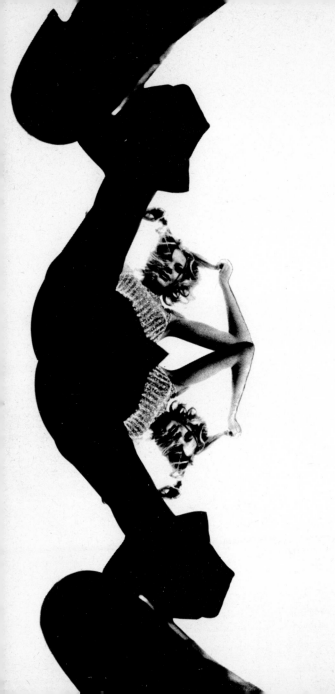

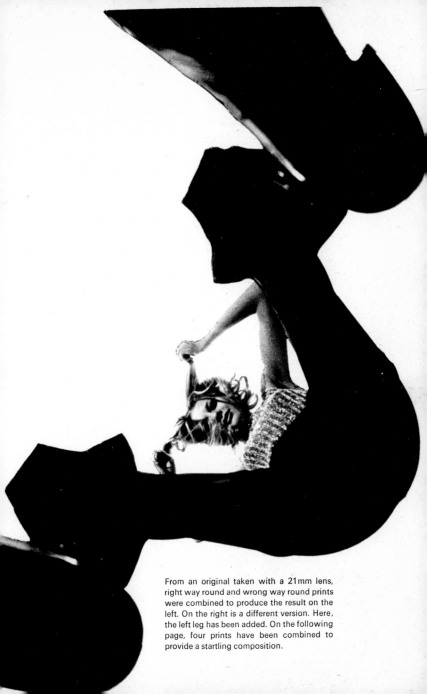

From an original taken with a 21mm lens, right way round and wrong way round prints were combined to produce the result on the left. On the right is a different version. Here, the left leg has been added. On the following page, four prints have been combined to provide a startling composition.

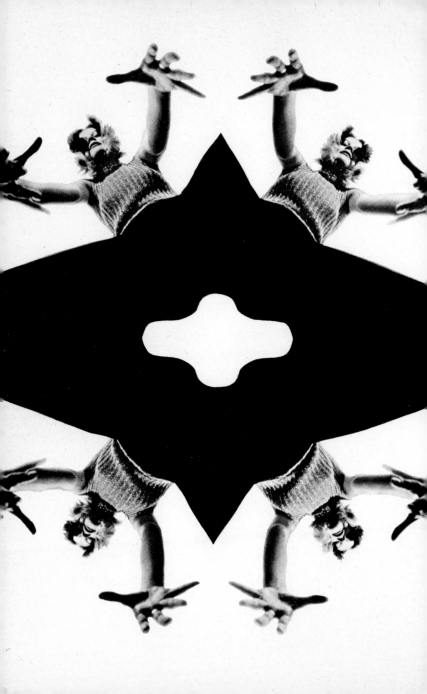

black, or pure red, such a picture will look coloured; the colours may be off-beam, but at least there will be no colour cast.

A blonde girl in a white bikini basking in the sun is not a particularly satisfying subject – at least not for the artificial-light colour film. The poor child would look as if she had just emerged from a huge inkwell; the beach scenery surrounding her will be affected in the same way.

But if the young lady is wearing a scarlet binkini, which anyway will probably be rendered too obtrusively on daylight colour film, we can risk the use of artificial-light film. Long black hair, like anything black, silhouette-like, contre jour, enhances the pictorial effect.

We are warned in old textbooks of colour photography of the spectre of mixed lighting (daylight + tungsten light), to be avoided like the plague. I have long overcome this prejudice and confess to a great weakness for it. I took a model in my room conventionally lit with tungsten light, on artificial-light film. But the background was supplied by the cloud-covered sky outside the window. It introduced a fascinating blue note into the picture.

I often use also a blue-tinted flashbulb or electronic flash to conjure beautiful blue onto a white wall in the background or onto some details of the subject, because these types of flash, balanced for daylight, behave towards artificial-light film like genuine sources of blue light. Naturally the difference in colour between tungsten light and flash can also be exploited to combine sharp features in bluish flashlight with an unsharp, artificial-light-illuminated and therefore correctly-coloured movement picture. Here is another tip: try to soften the shadows of outdoor subjects occasionally with flash through a warm filter (R12 or R16). The powerful Philips PF 5B flashbulb, too, is eminently suitable for this purpose.

Daylight film in artificial light

If we compare the possibilities of photographic colour composition on day light film with artificial light (photoflood lamps) with those on artificial-light film in daylight, daylight film will be definitely inferior.

Tungsten light converts all white, brownish and grey colours into not always pure brown-orange! Red hues will come through. Now orange-yellow and red are so closely related that they do not produce any particularly striking contrast. But what about green? I have seen an interesting and almost undegraded rendering of strong green on several occasions. But the character of the critical green colour will change completely even when the colour of the light shows a negligible change. It is hardly possible to predict how the greens will be reproduced. If they come out well this will always have been due to a little luck.

But quite apart from all problems of colour rendering, brown-orange, when it fills large areas in the picture, is much more objectionable than blue. There is only one remedy for this: areas of warm colour must be replaced as far as possible with neutral tones. If we introduce, for instance, a large piece of black velvet or the night sky as a background, the remaining orange-brown in the foreground will have lost most of its disturbing character. A white background – perhaps emphasized by overexposure – will have the same effect.

I think that although daylight film does not often produce exciting pictorial results in pure artificial light, it is eminently suitable for mixed lighting. A good example is the combination of sharp flashed and unsharp movement elements in front of a dark background, described in the previous section (artificial-light film in daylight), although in most pictures of this kind the warm artificial-light colour will still be obtrusive. To differentiate the various light colours even better, it is useful to mount a light blue filter in front of the flash lamp.

Light sources for way-out colours

Sources of flash can be simply converted into sources of coloured light with a great variety of aids – including the coloured paper used for building kites. Photographic lamps create some difficulties here. They generate so much heat that paper filters are liable to shrivel and glass filters to break.

Some firms, however, market a wide range of large-sized plastic colour-effect filters. These filter foils do not fry in the heat; at

worst they will warp, which does not improve their appearance; but their effectiveness will be preserved. Naturally, even plastic foils must not be mounted directly on the hot lamps. A certain distance must be maintained between light source and filter. The so-called "Lowel-light door" should be placed in front of the reflector-type photographic lamps. It is a two-wing attachment to be mounted directly on the bulb envelope and obtainable from the photographic trade. The filters can be fixed to the open wings with office clips or laundry pegs.

For my 1000 W halogen lamps I made a wire frame, which I mount in front of the lamp with the aid of a wire basket on each side. Here, too, the filter foils are fixed with laundry pegs at a distance of about 22 cm (9 in) from the bulb. Such frames are also commercially available for certain halogen lamps. Naturally with the filters in position I switch on light sources only as long as absolutely necessary for focusing and exposure. In the course of time you will have a goodly collection of various filters. I particularly like the Philips 100 W Comptalux Flood Colour window display lamps in red, yellow, green and blue. They are quite powerful enough for close-up subjects and even portraits, although they require somewhat longer exposures calling for the use of a tripod. These pressed-glass lamps with internal reflector fit the standard screw-sockets (Edison 27); they are available from photo- and from electrical dealers, where they usually have to be ordered in advance, with their type number specified. It may interest you that the layer of varnish of the window display lamp filters the light more strongly than most gelatine filters, especially in the blue and green lamps, which obviously absorb red and orange totally. This is of practical value in luminescence tricks (p 145), which will be successful only when narrowly filtered light is available.

Here is another point concerning exposure: as already pointed out (pp 12, 128) most exposure meters react excessively to red light. This means that you should open the stop about one step. Blue, on the other hand, has the opposite effect on the measuring instrument and therefore calls for shorter exposure – up to one step.

As a precaution check the behaviour of your own equipment in coloured light. Admittedly, however, "exact" illumination does

not play the same part in way-out colour composition, as when the colour character has to be more realistic.

Brief advice on way-out colour composition

I am quite aware of the fact that rules in photography, as in any other field, are sometimes academic. I am sure the best pictures derive their impact in the last resort from a deliberate violation of accepted rules.

On the other hand, you will find rules essential if you want to learn new techniques or one or the other photographic method. But I do not really intend to set up rules for composing with coloured light; I prefer to make only recommendations which will enable you to master the subject comparatively quickly. The word "rule" does not appeal to me. But I do not find the word "recommended", now that I have written it down, a happy choice either. What I really mean is a "list of what not to do". Wherever creative composition is the aim, we must outline what to avoid. Without a limiting framework, you can produce unlimited chaos, but you cannot achieve composition. Concerning colour composition, nine signposts may serve you as a rough guide to the possibilities open in this vast field:

1 No colour should uniformly tint the entire picture. At least one tiny picture element must supply a contrast with the basic colour. Here are two examples:

(a) Let us illuminate a group with red light. As compensation we produce a rim around at least one person with a green, blue or yellow contre-jour flash.

(b) Let us illuminate a still-life with two green Comptalux lamps and restore the balance by the orange glow of one or several candles (or fluorescent colours, p 145).

2 A colour threatening to drown the whole picture must be contrasted at least with black. Two examples:

(a) Let us suffuse a model completely with red or yellow light. As a background we use the black night sky or black velvet. Conversely a dark silhouette can stand out against a background illuminated by monochromatic light.

(b) Let us flash a woodcarving with yellow contre-jour light. The lamp must be arranged so closely behind the object that object and background are lost in blackness except for the light rim. A distant light source would soften the shadows in the room considerably.

3 A colour that tends to dominate the entire subject can also be confronted with white:

(a) Let us photograph a party with purple-filtered light sources. One lamp shines directly into the lens from the background. In the picture it appears overexposed, as a white patch surrounded by a colour fringe. The neutralizing effect of burnt-out, white contre-jour rims can also be usefully employed.

(b) Let us light a person with orange-red light. As a background we use a white, neutrally-lit surface or, simpler still, an overcast sky. The result will be a kind of coloured silhouette, but a silhouette with detail. The following variant is interesting: an unlit model is arranged in front of a colour-lit wall. The background must be overexposed to such an extent that it will appear white in the picture – and the model in a coloured hue.

4 Bright, contrasting colours may appear together in the same picture, but they must not face each other or both occupy large areas. Harmonious effects will be produced when the vigorous colours are distributed and intermixed as flakes, dots, or stripes. Two examples:

(a) Let us introduce light red and blue-green colours simultaneously into a still-life with a plaster figure. If we illuminate the left half of the figure bright red, the right half blue-green, the result would be rather shocking. But if we arrange, for instance, a grid lit in yellow-red, in front of the figure lit wholly blue-green, the two contrasting colours will harmoniously intermingle.

(b) Let us point two red Comptalux reflectors at a girl dancing in front of a black background; and expose for 1–2 seconds. In addition we fire blue-green flashes. Sharp blue-green flash elements will now interpenetrate with blurred, red movement tracks.

5 Violent, contrasting colours can be particularly well reconciled with each other by means of extensive areas of neutral colours. This expedient is used even by the pop artists, who are not particularly reticent with colours. Two examples:

(a) Let us illuminate various object details with red, green, blue

and yellow contre-jour light. The large shadow areas remain in the dark – black. The background should also be black, but could equally well be white.

(b) Let us illuminate a motley group with the most violent colours at random. Black clothes and black detail in the background will nevertheless ensure a harmonious colour effect. Naturally, exposure must be kept short enough for black to be rendered really black.

6 Of all the assorted colours, only one, dark blue, is capable of harmonizing glowing hues if it is used as a background colour. Although dark blue and black are not physically related there is, if I may say so, a character affinity between them. (The black of the night is preceded by the blue of the twilight.) This, incidentally, also explains the great importance in the composition of creative pictures of the blue cast of the artificial-light film used in daylight and with flash. Two examples:

(a) Let us illuminate a group with blue light, and beam yellow, green and red contre-jour or glancing light at various members of the group.

(b) Let us photograph a room in daylight with artificial-light film sources of coloured light – coloured Chinese lantern fitted with flash, Comptalux-Flood-Colour reflectors – are also included in the picture.

7 If the body colours of the object are vigorous, weak and even stronger colours of the light will in certain circumstances remain completely unnoticed. But if the object is mainly white, light grey, or green, even the slightest hue of the light will show up – usually unpleasantly – as a colour cast. Two examples:

(a) Let us make a portrait of a girl with a delicately green filtered flash. Her lips are so heavily made up that the red comes through in the picture and contrasts with the greenish hue of her complexion.

(b) We attach an orange conversion filter (R6) to the lens for a street scene on daylight colour film. As a counterpoint we take the green lamp of a traffic light prominently into the picture.

8 Compositions based on closely similar colours do not necessarily have a strong appeal, although sometimes their effect can be extraordinary. Combinations of blue and blue-green, yellow and orange, violet and purple, yellow-green and yellow light

promise success especially when the colour hues are subdued or when black, white, or grey are added to the picture composition. Here are two examples:

(a) A bronze figure is made to sparkle in green flashlight. The camera is loaded with artificial-light film. The background is provided by the deep-blue (because underexposed) sky.

(b) Drinking glasses are placed in violet, indirect light. A light source behind a purple filter creates reflections that enliven the subject.

9 Subjects of different hues lit monochromatically which may appear somewhat dull when seen in isolation can produce interesting effects by skilful contrast. Here are two examples:

(a) Borderless photographs of similar subjects, but in different colour hues, are arranged in an album on black cardboard.

(b) A section of an exclusively red and one of an exclusively blue-green lit transparency are combined in the same frame. They are separated by a black adhesive strip.

Here is a little tip: when you photograph a doll against a white background and light it with a red, a blue, and a green Comptalux reflector from the front and from the side, you will obtain fascinating coloured shadows on the white background wall or screen
 a truly fantastic effect.

Black-and-white filters in colour photography

As a rule, filters for black-and-white photography are very strong – very similar to the varnish film of the Comptalux lamps (p 139). Even stronger, denser and at the same time more colour-saturated are the process filters in red (Agfa Gevaert L 622, Kodak PM 29) green (U 531, PM 61), blue (U 449, BM 47) and yellow (L 489, PM 8).

They are gelatine filters, used, for instance, for the production of colour separation negatives in colour printing but also for a special type of colour enlarging (additive filter methods). You are often discouraged strongly, and quite rightly, from using black-and-white or process filters for work with colour reversal film. There are, of course, the exceptional situations which do not

comply with this rule. Such filters can be used for increasing the colour intensity whenever black shapes in front of a monochromatic background dominate the scene. Well-known examples are sunsets. By means of red filter we can emphasize the glow of the setting sun in a completely extravagant way – and reduce reality to merely a pale shadow!

Another trick: with the aid of hefty overexposures we can achieve a white sun suspended in a red sky above a black landscape. In addition, we can filter silhouettes and harsh contre-jour subjects. Another interesting effect can be produced as follows: a group of natural-coloured lighted candles is exposed three times, through a red, a blue and a green filter. During each exposure the flames are blown in a different direction. The result is that the flames are split into red, yellow, blue and green tongues. A basically similar effect can be obtained if waves moving across a sheet of water are photographed in partly contre-jour light with the three-filter method on Kodacolor colour negative film through the Wratten filters No. 25 (red), No. 61 (green), and No. 47 (blue). In these landscapes the rocks, the coastline – anything immobile – are reproduced in natural colours, whereas the agitated waves or the spray of the breakers iridesce in many hues.

It is certainly advisable to make such filtered treble exposures on negative film. It will be quite simple to adjust the natural colours at the printing stage if they have not quite come up to expectations. At the moment I am experimenting with Agfachrome 50 L artificial-light film and the Wratten No. 70 (deep red), No. 74 (deep green), and No. 98 (deep blue) filters, which are also suitable for colour separation work. My object was a simple glass of water. The colour-producing movement was caused by mineral water. I squirted a jet of water into the glass during each exposure. Since for multi-colour shots subjects containing dark, immobile and the brightest possible moving details are particularly suitable, I illuminated the bubbling water with contre-jour light. I was looking forward to the outcome with keen interest. The first result showed a quite incredible-looking pattern of bubbles in the picture.

These are the recommended exposure settings: with the blue and green filters $1/3$ of the values measured through the filters, with the red filter exactly the value measured through the red filter.

Red light produced by blue and green Comptalux lamps

What do you expect when you illuminate a subject with the pure blue light of the Comptalux Flood Color window display lamp? Naturally, a completely blue picture. You are right. Usually this is precisely what you get. But there are exceptions. Just point the blue lamps at certain types of yellow, yellow-green, red, and blue-red luminous paint or at objects painted with it in a completely dark room. Out of their blue surroundings these paints will glow in vivid red or yellow. This glow is due to the phenomenon of luminescence. The blue radiation excites the dyes to emit red and yellow light. This can be proved: all you have to do is observe a pot of luminous paint illuminated with blue light through an orange filter. The blue-absorbing filter will have the effect of making the pressed-glass condenser of the lamp all but invisible. The luminous paint, however, will appear luminously bright, or better, brightly luminous. I photographed this effect repeatedly.

This phenomenon is usually called fluorescence. It is based on the fact that short-wave rays are able to excite certain surfaces to emit longer-wave rays (the photographically active wave length region extends from the short ultra-violet through violet, blue, green, yellow, orange, red to infra-red). Normally fluorescence is excited with ultra-violet radiation, which has the advantage of affecting a large number of substances in this manner. So far the only substance I have succeeded in making fluoresce with blue light is luminous paint. (Experiments with some type of blue foil in front of halogen lamps showed here, too, the existence of weak fluorescence but it cannot be compared with the intensity of Comptalux-excited fluorescence).

At first glance, then, blue-light fluorescence does not appear to be very rewarding. A second glance, however, will reveal a different situation. We can, after all, "paint" details of some subject with yellow or red luminous paint. If the whole is now Comptalux-illuminated we shall obtain a picture in a monochrome blue hue, from which islands glow in different colours. As already mentioned (p 63), I am very fond of using blue-light fluorescence for compositions with revolving bodies.

I have also experimented with exposing luminous paints to green Comptalux lamps. Lo and behold, much to my own surprise, I was

able to make luminous bright red as well as luminous blue red fluoresce even with green light. This was not the first, nor is it likely to be the last, proof to me that it is always worthwhile carrying out experiments in photography which do not at first hold out much promise of success. Blue as well as green light fluorescence can be recorded both on artificial-light and on daylight colour film. The one emphasizes the green or blue superimposed reflection, the other the fluorescence a little more. Yellow, pink and orange filters in front of the lens also bring out the fluorescence more strongly by subduing the reflected light.

Needless to say the exposure meter reading should always be taken off the luminescent surface.

Properties of infra-red colour film

For some time exposure material has been on the market that has been dubbed "crazy-colour film". The official designation of this false-colour film is Ektachrome Infrared Aero 8443.

The creative possibilities opened up by this reversal material considered at length would burst this book at its seams. But since information about this subject can be found elsewhere, I may be allowed to confine myself to the most important details.

The film is available in 20-exposure 35 mm cartridges. It is advisable to order requirements in advance because storage presents some difficulties: the film should be kept at temperatures below 13.5° C; it therefore belongs in the refrigerator. A perforated strip in front of the film protects the emulsion against light. As a precaution transport the film in the camera to frame 2 or 3 if the first subject is an important one. In day- and flashlight the film must always be exposed through a filter. I use the types of filter which normally are suitable only for black-and-white photography. In my experience a light to medium orange filter has been found most effective.

The colour character of a landscape, for instance, changes with the filter used.

Even this limited information will prove that the colour rendering of a "crazy colour" film only rarely resembles that of a normal colour film.

FILTER EFFECTS ON INFRA-RED COLOUR FILM

Filter	Dominating colour tendency
none	purple to violet
yellow	blue, red
orange	optimum colour differentiation
red	yellow, red
infra-red (black)	deep red
green	blue, violet, sometimes purple

EFFECT OF INFRA-RED COLOUR FILM AND ORANGE FILTER

Colour	Rendering without infra-red reflection	Subject	Rendering with infra-red reflection	Subject
black	black	charred paper	red	certain black material
blue	black	blue sea	red	certain blue material and colours
green	blue	green sea, green paint, green traffic light, green reptile skin	purple to deep red	live green (grass, foliage)
yellow	bluish	gold	whitish	dandelion flower, birch bark
orange brown	greenish	skin tone (electronic flash-lit)	yellowish green	red roof tiles, skin colour (daylight, flashbulbs)
red	green	some types of lipstick	yellow	strawberry red apple
white	bluish	certain types of glass	white	white plaster

The material is extremely constrasty, which requires careful determination of the exposure. Since the infra-red proportion of the daylight is subject to fluctuations which the exposure meter will register only poorly if at all, the following information should be regarded as a guideline only. As a precaution take an additional exposure of interesting subjects at + and − half stop value each.

EXPOSURE OF INFRA-RED COLOUR FILM

Lighting	Exposure
Daylight, overcast sky, high sun	with light-to-medium orange filter, exposure as for 100 ASA 21 DIN
Morning and evening sunlight	with light-to-medium orange filter, exposure as for 160 ASA, 23 DIN
Photoflood (tests with 1000 W Philips PF 800 R halogen lamp, colour temperature 3400°K)	without filter, exposure as for 500 ASA, 28 DIN
Dark flash method: Kodak Wratten 87 black filter in front of a small flashlamp (tests with Philips PF 1B and AG 1B)	guide number 18. no filter in front of the lens

Here is another observation on the subject of flash: if the reflector of a flashlamp is made light-tight with the Wratten 87 gelatine filter, the flash will be invisible except for a very weak reddish glow. The infra-red colour film, however, records everything that the flash illuminates in deep red.
Fire and glowing embers, such as glowing cigarette end, are rendered particularly effectively and brilliantly by the infra-red colour film.

Way-out colour from black-and-white negatives

A large number of interesting methods are available for colouring black-and-white pictures in fancy colours, but this section concentrates on the optical colouring of negatives – a special colour

light printing method, with which two, and if necessary even three, colours can be applied to a black-and-white original.

The problem how to "colour" black-and-white pictures outside the darkroom without modification of the subject has also occupied my attention for quite some time.

A method of intensifying thin negatives which I am sure you are familiar with at long last pointed in the right direction. The emulsion side of the negative set up in front of a dark background is illuminated with glancing incident light (one lamp is sufficient at a minimum distance of 1 m (40 in) between the light source and the negative. Shorter distances require glancing illumination from both sides. Even quite slight densities will now light up comparatively brightly. The transparent areas hardly reflect the glancing light and therefore remain dark. We thus see the negative as a positive. If we reproduce the whole, a negative will appear on the film again, which, however, is considerably more vigorous than the original. Let us now illuminate a normally exposed negative, which should be as contrasty as possible, in this manner. We replace the black background with a white one, which is weakly lit. The luminous density of this area must be balanced so carefully, that, seen through the negative, it will appear still darker than the brightest portions of the picture sparkling in the glancing light, yet brighter than the very weakly sparkling details. If we photograph this set-up, the result will be a black-and-white negative containing simultaneously negative (glancingly lit) and positive (transilluminated) details. This special reproduction method results in an interesting kind of positive-negative combination.

There is only a small step from this black-and-white to a colour composition. We simply use coloured light, e. g. a blue Comptalux lamp for glancing light, and a red one for the background illumination.

Important: the glancing light source must be effectively screened from the background to avoid a saturation of the colour reflected by it. Reproduction on the most contrasty colour reversal film results in two-coloured transparencies. To my own surprise, my experiments with Agfachrome 50 L were successful at the first attempt. Careful brightness balance between the two colours is essential. Fortunately, the effect can be readily controlled with

the eye. If a background in two colours, illuminated with white light, is used, pictures in three colours are produced.

I must emphasize again that the black-and-white originals must be very contrasty. Soft originals should first be reproduced on document-copying film (p 122) or contour material.

Another point not to be ignored: dust granules are, as always, a nuisance. They reflect brightly and disturb the colour compositions severely. The negatives must therefore be carefully cleaned.

Sandwich tricks and other types of transparency montage

Slide lectures have changed from what they used to be about ten years ago; their impact has become stronger. Here are twelve well-tried ideas how to inject additional interest into colour slides for lectures with little effort and above all without a darkroom. Four of these montage processes enable you to introduce even movement into the picture during projection; they supplement and extend the possibilities inherent in the projector of enlivening the pictures, such as rotation of the slide stage, change of the image size with a zoom lens, or the use of an Iscorama attachment (p 106).

The great majority of the montage tricks – nine out of twelve – is based on the sandwich principle. This involves the arrangement of two or more slides or additional material one behind the other(s). Very light transparencies – overexposed ½ to 1 stop – should be used for such montages, so that the final picture will not be too dark: the superimposed colour densities add up. Incidentally, you can always salvage valuable, but unfortunately slightly thin, light transparencies by means of the sandwich method. Have two identical transparencies made of the picture in question, and mount them in precise register on the light box. The edges of the transparencies should be bound together with adhesive tape. This montage can be directly projected or duplicated yet again. The result is considerably increased contrast and colour saturation of the picture.

Although simple duplication of overexposed transparencies leads to a darker reproduction, it does not appreciably improve the colour saturation. Which brings us to our twelve possibilities:

1 Combination of two suitable colour transparencies. The subjects may be conventional or eccentric. Maximum sharpness in projection is obtained when the two components are mounted so that emulsion sides face each other (pure sandwich principle). For this purpose one of the transparencies must be inserted wrong-way-round in the frame. But montage of emulsion side/back is also possible (if necessary have a duplicate made). In contrast with multiple exposure (p 14) but exactly as in photomontage, the subjects of the separate pictures will show up particularly well if their backgrounds are extremely light.

2 Combination of a colour and a black-and-white transparency (or negative). Contrasty black-and-white subjects or those reproduced on contrasty material are particularly suitable for this method. Especially decorative are positive or negative silhouettes, bound together with colour transparencies of coloured structures. I have used such montages for livening-up sound-coupled slide lectures – quite successfully I believe. You might well want to experiment with harsh contre-jour subjects or copies on film of Agfacontour composition.

3 Combination of colour or black-and-white transparencies with coloured screen foils. The process screens are available not only in black, but also in red, blue and green. Colour transparencies can, if necessary, be built up even with the aid of a layer of thin fabric, tissue paper or similar material. If the montage turns out too dark, lighter duplicates are printed.

4 Combination of two identical transparencies emulsion side/back. These must be pictures of identical areas – either duplicates or transparencies photographed from a tripod in rapid succession. If these are first brought into register and then slightly rotated against each other a delicate circular structure appears. But the extent of the rotation must be carefully matched. Furthermore, the circular shape is shown only by montage slides containing a great deal of minute detail, such as foliage, grass, patterned fabric, tree bark, mosaics.

5 Combination of two identical transparencies or duplicates, emulsion sides facing each other. This necessarily requires wrong-way-round insertion of one transparency in the frame. The result: the sandwich acquires an axial symmetrical character.

6 Combination of a colour transparency with a delicate black-

and-white negative contact copy. Slightly displaced sideways, the two pictures produce a noticeable relief effect.

7 Combination of a colour transparency with a contrasty black-and-white positive copy. The copy (of course produced in contact like the intermediate negative) must be exposed on contrasty process material. Original colour transparency and positive copy produce a contrasty composition of graphic effect of suitable subjects.

Better still: instead of a straightforward black-and-white slide use a copy on film of an Agfacontour copy for your montage.

8 Combination of up to three transparencies with light backgrounds with space between the emulsion layers (motion effect). The individual transparencies must be mounted in cardboard frames which are then glued together. This provides ''air'' between the slides. During projection the sharpness can be shifted to the viewers' puzzlement at will between the various pictures by adjustment of the projector lens. (This will be the more successful the shorter the focal length of the projector lens.)

The backgrounds of the pictures should be white. By slight overexposure these lightest portions must be kept so transparent that if necessary they can compete with a window pane. Combinations whose components have been photographed so that their subjects do not overlap after montage also deserve interest.

9 Combination of a transparency with Cellophane and polarizing-filter foil (movement effect). The coverglass facing the light source in the projector must be replaced by a piece of polarizing-filter foil. In front of this we arrange the transparency and some folded Cellophane. A second polarizing filter, rotated in front of the projector lens, makes the portions covered by Cellophane glow in changing colours; those not covered by it appear alternately dark and more or less bright.

10 Combination of duplicates into a block of four. Four duplicates of preferably a graphic subject are mounted side by side and one below the other with narrow black adhesive strips, forming a block of four. The arrangement of the pictures is as follows:

top left	right-way-round
top right	wrong-way-round
bottom left	wrong-way-round upside-down
bottom right	right-way-round upside-down

A

B

Colour	+	Colour
Colour	+	B & W Positive
Colour	+	B & W Negative
Colour	+	Cel.
B & W	+	Cel.

Sandwich slide effects. A, When slides are sandwiched, the greatest overall sharpness is obtained if they are placed emulsion to emulsion. B, The types of sandwich that can be made are almost limitless.

The result is a central symmetrical arrangement. The montage, measuring about 50 × 75 mm, can be reduced by an optical printing process so that it can be shown with a 35 mm projector. If it is possible to reduce the width of the picture from 36 mm to 29 mm without loss of impact they will fit in a 7 × 7 cm (2³/₄ × 2¹/₄ in) frame for 6 × 6 cm (2¹/₄ × 2¹/₄ in) projection. Four duplicate sections of 19 × 19 mm can also be easily combined in a block of four, but this requires a certain amount of delicate touch. An interesting application is to show blocks of pictures with several magnetic-tape-controlled projectors (multivision).

11 Combination of blocks of four with linearly as well as circularly polarizing filters (movement effect). Again the coverglass facing the projector lamp is replaced with a polarizing filter. In addition, two pieces of circularly polarizing filter (p . . .) are cut to the size of an individual picture and arranged between the first polarizing filter and two opposing quarters of the block of four. Yet another polarizing filter held in front of the projector lens makes the two diagonally opposed pairs of pictures alternately disappear completely, depending on its rotation position. At intermediate positions all four pictures are visible, but at more or less reduced brightness.

12 Combination of several (panoramic) transparencies arranged side by side (movement effect). Suitable transparencies – they may be panoramic series – are mounted with adhesive tape on two oblong strips of glass of about 5 cm (2 in) width. After the removal of the slide stage, the strip can be moved across the condenser in certain non-automatic projectors (wandering panorama effect).

Arrangement of colour paper prints on coloured supports

Borderless colour prints appear more luminous on grey than on white paper, and more brilliant on black than on grey paper. A coloured background can greatly enhance the pictorial effect: it can also completely spoil it.

Aesthetic effects are assured if two basic rules are observed. The background should be in a colour that also occurs in the picture – either covering large areas, or, as vivid colours, in small dots

on pictorially important details. The background may also be in a tone that contrasts with prominent colours of the pictures; but brightness and saturation of the two complementary colours must roughly match.

The arrangement of colour pictures on coloured background is a somewhat dubious method. Even pictures of little inherent merit can be attractively presented with it. Ingenious effects will be created if several pictures in different colours are contrasted with one another on a coloured background. Sometimes they can be textured by means of a coloured printing screen mounted on them.

Unusual
Effects and
Combinations

You will come across the mirror as an aid to tricks very frequently in this book. It doesn't matter if it breaks; you can make use of the fragments for a photograph. A portrait, for instance, that is reflected in picturesquely scattered fragments arranged with gaps between them on black background reminds us, with its broken-up structure, of the anguish of our mortality.

Mirror craft

Subjects reflected in a plane mirror can radiate dreamlike fascination if the reflected image itself is very sharp but the surroundings of the mirror appear completely blurred. To achieve this, the distance between camera and mirror must be kept comparatively short and that between the mirror and the object comparatively large. The lens must be focused on the total distance from camera to mirror to object and the lens aperture must be large.

An interesting effect is created if crumpled strips of silver paper are placed right across the mirror to produce circles of unsharpness superimposed on the mirror image. Striking effects also result if the mirror image and the surroundings of the mirror are lit in different colours.

If you let a plane mirror, with its reflecting surface facing the camera a little obliquely, drop through the object field, you will get a more puzzling result. This is worth trying! An unsharp band showing a picture will appear. If the exposure is right, the background can peer through. If the mirror twists during its fall, the picture will become distorted. You will be successful only with a plane mirror – if one mirror is enough!

Besides proper mirrors you can of course use also glossy foil, water puddles, and simple glass panes in mirror-trick photography. Metal mirrors, however, behave somewhat differently from all other reflecting surfaces. Irrespective of the angle at which our eye or our camera lines up the metal mirror, the brightness of the reflection will always be roughly the same. The general falling-off of the luminous density of the reflected image compared with the original is of the order of a little less than $1/2$ lens stop with ordinary mirrors, and 1 lens stop with highly reflecting surfaces.

Window panes and sheets of water reflect the more strongly the

Mirror tricks. A, Filtered lights illuminate the background. Objects behind the camera are reflected in the glass. B, Mirror with crumpled foil attached can be dropped or pulled through image area. C, Angled mirrors produce multiple images. D, Patterns added to angled mirror images by reflection of coloured scraps. E, Silver foil on mirror front to break up reflected image. F, Combination of glass sheet and mirror. G, Pieces of mirror and glass and coloured objects on mirror.

more oblique the angle of reflection, i. e. the more oblique the alignment angle between camera and reflecting surface. If the camera points at a surface at right angles, hardly anything will be seen of the reflection. At an angle of 75°, however, the reflection will already be strong enough to call for an exposure increase of no more than 2 lens stops. ($1/2$ lens stop at 86°.) It is of course well known that a polarizing filter can extinguish reflections at an oblique angle. But it is less well known that in the opposite rotation position of the filter the reflection will be brought out a little more strongly compared with its surroundings.

Obliquely sighted glass panes produce an effect which resembles double exposure: the combination of a reflected object, with the original arranged behind it.

Curved mirror surfaces produce distorted pictures. Among the distorting mirror surfaces you might meet are:

Sheet of water with waves

Sagging high-gloss foil

High-gloss foil lying in a dish filled with water. The water must be slightly agitated

Christmas tree globe, whole or as a collection of fragments

Dark china teapot

Shiny inside of a ladle

Shaving mirror.

When the mirror surface is spherical or cylindrical the reduced or narrowed image is optically a little closer to the camera than the improvised distorting mirror itself. Conversely, with concave spherical mirrors and troughs, the magnified or widened image formed at close range appears at a much greater distance.

The upside-down or narrowed image produced at a long camera distance on the other hand is again closer to the camera than the mirror. This means in practice that with the aid of a shaving mirror a close-up and a more distant reflected object can be rendered sharp at the same time.

Improvised trick lenses

From a glass button to a piece of rock crystal all kinds of glass objects can be attached to the lens. If these attachments are pris-

matically ground, the same rules apply as to the trick lens practice (p 113). An interesting new medium is the glass brick. If it is arranged at some distance in front of the lens and a subject in the constrastiest possible lighting sighted through it, the oddest distortions will be observed.

All glass vessels even remotely resembling cylindrical, conical or spherical shapes act similarly to collecting lenses, except that they distort more strongly. But they must be filled with a liquid. A head, for instance, may be reflected in a glass vase, a champagne glass, a brandy glass or similar vessel that has been filled to the brim.

To focus on this image with perfect precision a slightly longer distance than that corresponding to the distance between camera and vessels ought to be chosen. But the difference between the two distances is so slight that we usually achieve our aim with radical stopping down.

Occasionally I even let my camera look through spectacles, but at a certain distance so that both spectacle lenses are included in the object field. Spectacles for shortsighted people require the camera lens to be focused on a distance shorter than that of the object.

What is the purpose of this manoeuvre? Well, the details seen through the spectacle lenses appear sharp, those not covered by the spectacles completely, and the frame usually a little, unsharp. Colour photographs through ground sunglasses turn out particularly striking.

Glass dessert plates, bottoms of glass bowls, and drinking glasses offer an almost inexhaustible fund of patterns. But there is little point simply to hold them in front of the camera lens. This would distort the subject excessively. You can arrange coloured surfaces, in reflected or transmitted light, underneath the glass patterns.

This results in attractive colour shapes, of which you can photograph close-up or magnified portions.

The coloured structures, which are suitable also for sandwich compositions (p 150) change as you rotate the glasses, vary the distance to the coloured underground or displace the plane of sharpness. I also like to transilluminate such glass patterns with coloured light sources.

Bubbles

Years ago I took a photograph of a green leaf. It had a special attraction: a "necklace" of the most delicate sparkling pearls tracing its outline. They were air bubbles adhering to the leaf, which was submerged in water.

This is achieved as follows: some object is placed in a glass vessel filled with tap water, which should be as cold as possible. In the course of a few hours the water, acquiring room temperature, expels air bubbles, which adhere to the objects and unfortunately also the wall of the glass; they must be gently removed, with a knitting needle, perhaps. During the time of waiting the glass should, if possible, be left undisturbed; any movement will dislodge many bubbles, which will rise to the surface.

I am too impatient for such time-consuming experiments and therefore decided to use mineral water for such compositions. This cuts the time of waiting down to a few minutes.

In mineral water the bubbles settling on the various objects are larger and more beautiful than in tap water. Furthermore, CO_2 bubbles have the advantage of less tendency to cling to the glass walls. On the other hand, gas bubbles will insist on rising from the bottom of the vessel to the surface right through the middle of the object field. But long exposure times – between, say, 3 and 10 seconds – will suppress any trace of them in the picture. The lighting should always be contre-jour.

Like the gas bubble picture on page 103, another I tried was taken in coloured illumination; the occasion having been a New Year's Eve celebration, I was outrageously extravagant: I bathed the office clip in champagne instead of prosaic mineral water.

This produced a very strange phenomenon, which I was unable to explain: after the tenth or eleventh exposure I clearly saw two clips in the viewfinder of my Leicaflex SL.

Metals in coloured illumination

Metals – both shiny and reflecting – are ideal subjects for coloured illumination. This is caused by their characteristic type of reflection, in which not only bright, coloured highlights play their

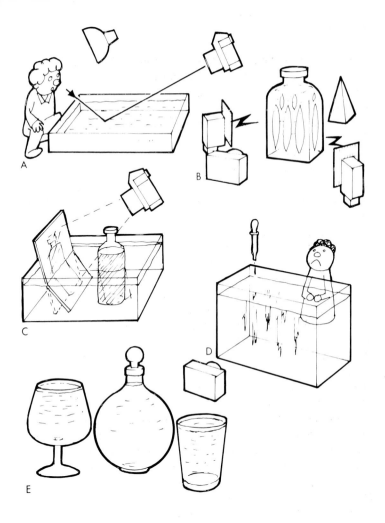

Water effects. A, Reflections in water can be distorted if the surface is slightly rippled. B, Shooting through a cut-glass vessel illuminated by coloured lights. C, Photographing water-refracted images. D, Shooting through a glass tank with coloured pigments dropped in. E, Vessels suitable for providing distorted images of various shapes.

part; dark portions, too, are preserved. But according to our colour rules (p 140) neutral black is very useful for harmonizing prominent splashes of colour.

Shiny metal, such as crumpled silver paper, sometimes need not be lit in colour at all. A colour composition can be based simply on the arrangement of sheets of coloured cardboard so that they are reflected in the direction of the camera lens.

I am particularly fond of illuminating details of tools in colour: details of screwdrivers, nails, pliers, close-ups of technical appliances. The resulting slides often look fantastically unlike their mundane subject matter.

The romantic colour illumination of tools is not without significance in our day and age. Romanticism persists, except that its objects differ from those of a hundred years ago. Whereas in those days they were beautiful or heroic Nature, beautiful or heroic art, preferably in the form of crumbling ruins steeped in ancient history, today we gradually accept technical objects, veteran cars, railway engines, etc. as romantic. My own bookshelves are graced by a solid brass microscope and a mahogany field camera, both at least 90 years old. But modern technology, too, is seen in a romantic light, especially industrial scrap (corresponding to the ruins of old). It is the focus of the utterly romantic pop art, which claims to unmask the world we live in, but idealizes it instead.

It really does make sense that in an age when old objects of romanticism are replaced by new ones we illuminate tools and machinery in an idealizing coloured light – even if it is only a nail in the wall which comes out blue on artificial light film, but reflects a little red from an ordinary tungsten lamp.

Combinations of objects

Different objects can be combined in a picture in different ways. I am trying to list the most popular methods in as lucid a manner as possible. It is up to you whether you are going to compose pictures of associated objects, or create eccentric arrangements of contrasting ones. You might be tempted to photograph a bar of chocolate with a dab of mustard, try to make a slice of tomato as-

sume the function of a monocle, or let a lady in a festive gown carefully open a tin of oxtail soup with a charge of dynamite.

Be that as it may – I know of a total of 13 methods of combination, which I am going to suggest to you:

A large foreground subject is combined with one in the background taken at a much smaller scale with the aid of an (ultra) wide-angle or fisheye lens or a panoramic camera.

The method in which part of an object is made to symbolize the whole is also most simply realized with lenses of short focal lengths. A small, yet characteristic part of an object in the foreground is combined with an object in the background.

One subject appears sharp in the foreground, the other unsharp in the background (long focal length, large aperture). Blurred objects look somewhat more unreal than sharp ones, at the same time their general validity seems to be enhanced.

Naturally, we can also render the foreground object blurred. It will then partly obscure the sharp object in the background.

Even when two objects are at the same distance, one can be rendered sharp, the other unsharp. For this purpose a grease mask is used. This is a piece of glass partly covered with Vaseline and held in front of the camera lens. The same effect can also be introduced at the enlarging stage.

A mirror (it could also be a puddle or a window pane sighted obliquely) forms part of the surroundings of a close-up object.

It will reflect a more distant object.

In a full glass, which is part of the first object, a second, background object appears sharp.

An obliquely arranged glass pane combines a reflection with a transparent view.

Two different subjects are combined by means of double exposure (p 14). The sandwich method naturally is also suitable for the combination of initially unrelated objects (p 150).

Among the various cut montage possibilities the importance of the collage in object combination is particularly noteworthy (p 125). Finally, a subject can also be included in another in the form of a picture on paper, of a drawing, or of a projected slide (back projection). The shadow method appears sometimes mysterious, indeed: the black or coloured shadow of an object falls across another object.

The simple subject

This book deals with photographic methods – and only marginally with photographic subjects. Both for conventional and for eccentric photographic methods simple objects are the most suitable yardsticks. In photographic colleges the students are very often given the simplest of simple objects – an egg. And in many a hand such a simple egg has become Columbus's Egg. This transformation of an object can take place either at the exposure or at the processing stage in the darkroom. Here we are interested only in the exposure.

The most important possibilities of influencing the result are:

Choice of film type
camera viewpoint
determination of the object area
distance between camera and object in connection with the
 choice of focal length
focusing
stopping down
illumination
choice of light colour
combination of the object with a background
combination of the object with another object
adjustment of the sharpness of the surroundings of the object
distortion of the object by optical means
introduction of the object into an unusual medium (e. g. a liquid)
movement of the camera during the exposure
change of the focal length of the camera lens during the exposure
movement of the object
distortion of the object
destruction of the object.

Not only the enrichment of the object by additional features, or its multiplication, indeed also its apparent or real deformation can be a pictorially creative act. By "apparent deformation" I mean that the object is rendered indistinctly in the picture.
In my personal work I carry this method very far although not as far as the complete destruction of the rendering. This is why:

166

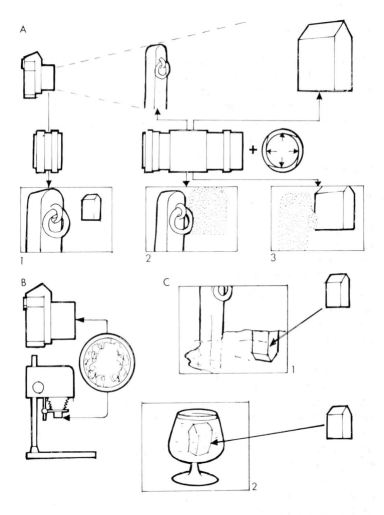

Combining objects. A, Near and far objects combined. 1, A wide angle lens used close up gives perspective distortion. 2, A long focus lens at wide aperture focused on the near object gives a defocused image of the far object. 3, The reverse effect is obtained by focusing on the far object. B, A filter or glass partly smeared with petroleum jelly can provide sharp and unsharp objects when used on camera or enlarger. C, Using reflections, 1, Combining near object with reflection of distant object. 2, Photographing distorted reflection in suitably shaped vessel.

Factors influencing results, 1, Choice of film. 2, Camera viewpoint. 3, Placing in image area. 4, Choice of focal length. 5, Focused distance. 6, Choice of aperture. 7, Type of illumination. 8, Colour of light. 9, Combination with background. 10, Combination with

other objects. 11, Varying sharpness of surroundings. 12, Optical distortion. 14, Photographing through liquid. 15, Moving camera during exposure. 16, Zooming during exposure. 17, Moving the object. 18, Distorting the object.

since the object must be present at the moment of exposure, the photographic medium, more than all the other forms based on creative activity, has a duty to reproduce it. In spite of all my love of experimenting I want to see a measure of resemblance of the object preserved. I want my pictures to remain likenesses – if need be on the borderline of what is acceptable. In extreme cases it may – paradoxical as it may sound – be only the caption of the picture that conveys to the viewer the pictorial character of the photograph. Don't misunderstand me: photography cannot be separated from reality, but it is not able to produce an "image of true reality". I believe that every photograph is an interpretation of reality, exactly like the perception of our eye, and as such a contribution to the picture we have of our environment. This does not by any means detract from the value of a photograph, for we can perceive any feature of our environment only when it has been transformed into an image of our imagination. I would therefore replace the dogma of "photography, the optical fixation of reality" by the idea that photography is a "vehicle of intellectual and emotional absorption of reality", i. e. not reality itself; it merely conveys it.

But if a photograph has such an intimate relationship to its object, what is the point of creative deformation of reality in the picture? The right to do this can be derived from the blindness of the human brain to all features with which it is, or thinks it is, too familiar. What is difficult to interpret, on the other hand, attracts attention, is seen with excessive clarity. Fantastic photographic practices draw the veil of mystery across hackneyed subjects. It is this veil which by half hiding, half revealing, excites the brain as well as the heart. It is the veil that fascinates, not the all-concealing blanket, nor complete revelation.

It is not the final knowledge that makes man happy, but the process of learning. If we thus isolate our motifs from the conventional arrangement we create a new order – a paradise full of secrets and adventures – is this not an indispensable part of happiness?

Index